THIS BOOK IS PUBLISHED
ON THE OCCASION OF THE EXHIBITION
THE HENRY P. MCILHENNY COLLECTION
IN MEMORY OF
FRANCES P. MCILHENNY
PHILADELPHIA MUSEUM OF ART
NOVEMBER 22, 1987—JANUARY 17, 1988

MADE POSSIBLE BY A GRANT FROM
PROVIDENT NATIONAL BANK
AND
PNC FINANCIAL CORP
WITH ADDITIONAL SUPPORT FROM
THE PEW CHARITABLE TRUSTS

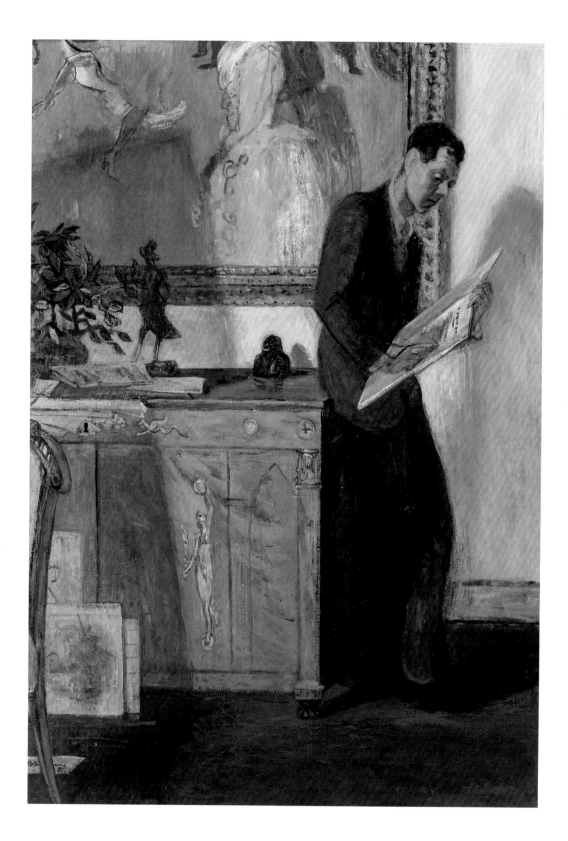

THE
HENRY P. McILHENNY
COLLECTION

AN ILLUSTRATED HISTORY

JOSEPH J. RISHEL

with the assistance of Alice Lefton

PHILADELPHIA MUSEUM OF ART

1987

FRONTISPIECE
Franklin C. Watkins
American, 1894–1972
Portrait of Henry P. McIlhenny, 1941
Oil on canvas, 47 x 33″

Conceived and designed by George H. Marcus
with typography by William J. Boehm

Photographs by Eric Mitchell
and Will Brown (pages 90, 97, 131)
Gloria Etting (pages 84, 101)
George Platt Lynes (page 104)
Joseph Mikuliak (pages 41, 44, 47, 62, 71, 93, 124)

Composition by Meriden-Stinehour Press
Lunenburg, Vermont

Separations and printing by
Lebanon Valley Offset, Annville, Pennsylvania

Copyright 1987 by the Philadelphia Museum of Art
Box 7646, Philadelphia, PA 19101
All rights reserved.

Library of Congress Catalogue Card Number: 87–29196
ISBN 0–87633–073–1

CONTENTS

PREFACE

❧

THE UNTIMELY DEATH OF HENRY P. MCILHENNY ON MAY 11, 1986, was a severe blow to the Philadelphia Museum of Art and to the cultural life of this city. Like his father, John D. McIlhenny (1866–1925), his mother, Frances Plumer McIlhenny (1869–1943), and his sister, Bernice McIlhenny Wintersteen (1903–1986), he played a vital role in the history of this institution and in its continued, dynamic growth. In bequeathing his collection to the Museum, he acted with a degree of generosity and professional insight that, while completely in character, was overwhelming in its declaration of commitment to this institution and to the city itself. Despite his absolute ease in an international sphere, Henry McIlhenny always thought of himself as a Philadelphian and as an integral part of the life of this Museum. His will is truly a model of artistic philanthropy. The testament falls into two simple sections. A list of some fifty works, principally nineteenth-century French paintings and drawings, those of extraordinary quality and importance that gave him world fame as a collector, was drawn up; the trustees of the Museum had thirty days to accept them; if any were rejected, they would go to the Fogg Art Museum at Harvard University. (If rejected in turn by the Fogg, the income from their sale would go to the Philadelphia Museum of Art.) It will come as no surprise that the Museum's gain was Harvard's loss. All other works of art in his possession were willed to the Museum as well, with the understanding that within six months the staff would select those it felt would add most to the collections of each department; those not chosen would be sold at public auction, the proceeds joining an acquisition fund also established through a financial bequest provided by his will. All the works accepted by the Museum, as well as any added through future purchases, were to form the Henry P. McIlhenny Collection given in memory of Frances P. McIlhenny. There was no

requirement that the whole or any part of the collection be shown together as a memorial.

The selection process was arduous and demanding. Object after object was examined with vivid awareness of McIlhenny's own discriminating judgment, as we were keenly alert to the needs and requirements of the present collections that he knew so well and that, in many cases, he helped form during his professional involvement as a curator between 1934 and 1964. As aware as we were of the immense pleasure he took in acquiring beautiful things, we still found the number of works to be considered formidable. The Museum ultimately accepted 414 works in a diversity of styles and mediums, and from many historical periods. The sale of the remaining collection, held at Christie, Manson & Woods International, Inc., in New York on May 20 and 21, 1987, contained more than 900 objects and brought 3.3 million dollars to the McIlhenny acquisition fund.

Plans to show Henry McIlhenny's collection as a special exhibition were begun during his own lifetime in the conviction that it would be both fitting and exciting to undertake the project while he was still able to play an active part in the cataloguing process and to critique our selection. He even agreed to move out of 1914 Rittenhouse Square for the duration of the exhibition in order to make a truly representative selection possible. Sections of the collection, particularly the celebrated nineteenth-century French paintings and drawings, have often been shown as a group in the past—in San Francisco (1962), Allentown (1977), Pittsburgh (1979), Atlanta (1984), and most recently, Boston (1986). Over the years the key works often formed part of summer loan exhibitions at this Museum during McIlhenny's travels to Ireland and abroad. However, at no other time has a large selection of works suggesting the remarkable range and diversity of his interests been presented. We had hoped initially to provide a full catalogue of the collection upon this occasion, but the quantity and scope of material, which literally draws upon the resources of each and every department of this institution, made this impossible. The task of preparing detailed catalogue entries on individual objects awaits research and publication by those departments in which McIlhenny's objects will now constitute some of

their most important holdings. To celebrate the extraordinary generosity and sweep of the bequest, this illustrated survey of the collection accompanies Joseph Rishel's vivid biographical essay on Henry McIlhenny's career as a collector and a curator.

In undertaking to write the catalogue text and organize this exhibition, Mr. Rishel, curator of European painting, assumed a large and complex task with an energy and dedication for which we are deeply grateful. We join him, in turn, in expressing heartfelt thanks to all the family, friends, and colleagues of Henry McIlhenny, and to the members of this Museum's staff, who helped in myriad ways. George Marcus, head of publications, conceived and carried out the elegant format for this book, and Cleo Nichols, as guest designer for the installation, gave the exhibition a graceful setting. Funds contributed by Mrs. Donald A. Petrie and Mrs. Graham S. Cummin supported the initial research for this project, which has also benefited, as have so many Museum exhibitions, from the generosity of The Pew Charitable Trusts. Without the extraordinarily handsome grant from Provident National Bank and PNC Financial Corp, neither the exhibition nor this book would have been possible.

Henry McIlhenny's legacy as a donor and his almost daily participation in the dynamic life of this Museum for more than fifty years will continue to affect the fundamental character of the institution, providing both a remarkably high standard to be maintained and a splendid addition to the great works of art now available to the public. His bequest was perfectly consistent with his life, which touched so many. Venturing to speak for everyone who contemplates the haunting theater of Degas's *Interior* or the exuberant gaiety of Toulouse-Lautrec's *At the Moulin Rouge*, and who admires the sophisticated charm of a Charles X chair or the forceful certitude of the Pacot silver centerpiece, we are all profoundly indebted to this remarkable man, whose legendary hospitality is now extended to future generations.

<div style="text-align:center">

Robert Montgomery Scott Anne d'Harnoncourt
 President *The George D. Widener Director*

</div>

GROWING UP

1910–1929

HENRY MCILHENNY, AS HE HIMSELF OFTEN NOTED, WAS born into a family of collectors. Although his father died when Henry was still a boy, John D. McIlhenny provided a standard of seriousness and generosity, particularly in the visual arts, that governed much of his children's later years. This was made very clear in a talk Henry McIlhenny gave at the Philadelphia Museum of Art, in which he expressed deep affection for his father and showed the continuing strong influence he had:

> *I was only fifteen when my father died in 1925, but I do remember him very clearly. But how can I present him to you? First, his background must be investigated. He was 100 percent Irish by ancestry. His father, John, was born in County Donegal in 1830, of Scottish origin and a member of the Protestant Church of Ireland. And when his father, James, a shopkeeper in the town of Milford . . . died, his widowed mother in 1844, before the famine, brought her four children to Philadelphia. Here my grandfather met and married another Irish emigrant, Berenice Bell, a Presbyterian of French Huguenot origin . . . from Armagh. Married in 1855 they moved south, the young couple, and settled in 1857 in Columbus, Georgia, where they quickly became prominent citizens, my grandfather like so many Irish, entering politics and becoming mayor of Columbus immediately after the Civil War, during which he had lost all of his possessions.*
>
> *He started the public school system of Columbus, and today a school bears his name. His business was public utilities, meaning gas. He very cleverly invented the gas meter, God bless it, and in the late seventies returned to Philadelphia to form the firm of*

9

Helme and McIlhenny, the descendant of which still has almost a monopoly on gas meters, I believe.

So my father, born in Columbus in 1866, was brought to this city as a teenager. He did not go to college but entered the family firm, and then branched out in the utility field, buying up companies, putting them on their feet, and then selling them again at a profit. In 1898 he married in Pittsburgh my mother Frances Galbraith Plumer, a native of Franklin, Pennsylvania, who had been "finished" in Paris and Dresden. Theirs was a happy marriage.

Now what was my father like? He had a rather Southern voice, and all his life used Southern words like "reckon" instead of "think"; but he didn't have a broad Georgian accent. Thank God! He was very fastidious and particular, and extremely neat, and dressed impeccably. He played golf regularly, and I suspect badly, and adored fly fishing in the Poconos. He valued good food and fine wine (no alcohol, however, was served in his house during Prohibition) and he traveled in style, always with the best suite available.

When motoring he disliked overcrowding, so he always hired two cars, one for himself and my mother, the second for my sister and me, who rode behind. We got all the dust! His manner was slightly stiff and he gave an impression of distinction. One can't imagine telling him a dirty joke, and he had a sharp tongue.

My father bought the public utilities company in Norristown, Pennsylvania, Three Counties Gas and Electric; and one of the leading families there was Lees, of the carpet firm that Joe Eastwick now runs. A rich Miss Lees had married a clergyman, Charles F. Williams, but who gave up calling, it was said, because of epilepsy, and so he became an ardent art collector, chiefly of Oriental carpets, so suitable for the family carpet business. The Williamses had become figures in the art world, so when my father went to pay his respects he saw a pile of Oriental carpets in the hall, waiting to be returned to a dealer in New York. In 1908 my parents were building a new house in Germantown [Parkgate, at Lincoln Drive and Johnson Street] and needed more rugs, so

my father bought the pile rejected by Williams. With that act, he was hooked. He became a passionate collector of Oriental carpets. He really loved them, despite the fact that he was color blind! I remember as a child how irritated he was by not being able to find wild strawberries.

So the collecting started, and my mother, who had innate good taste and a flair for quality, shared and encouraged his enthusiasm. She too became a passionate collector. Through the Williamses, my parents met people of the art world: art historians, curators at the Metropolitan Museum in New York and elsewhere in time, and, of course, the dealers. Just the other day I found a letter to them from Mary Berenson; and when they went abroad after World War I they knew the great Berenson himself, Charles Loeser, and Richard Offner,[1] among many others, but it was the Williamses who launched them into this new world of art. . . . My parents naturally became known as collectors, and my father soon became a member of the board of this Museum, then housed in dear old Memorial Hall. In 1918 he was elected president, a post he held until his death in 1925, at the age of fifty-nine.

John D. McIlhenny's carpet collection was indeed one of the finest of its kind and remains a cornerstone of the holdings at the Philadelphia Museum of Art, thanks to his bequest.[2] The systematic pursuit of the best in this area was certainly a great source of pride for Henry. That the pursuit was not without its sad turns, however, is evidenced by the tale he often told, firmly but with a cautionary air of irony, concerning the Marquand carpet, a famous medallion and animal carpet that his mother purchased in 1932 to add, eventually, to her husband's gift to the Museum, in fact, to be its final glory. At the time, it was thought to be a rug from the court of the sixteenth century Persian Shah Tahmasp and was considered the most significant in the collection. Later, however, it was recognized as an extraordinarily fine mid-nineteenth-century imperial revival rug, and Henry McIlhenny never ceased to remind curators at the Museum that at the time of its purchase he had been encouraging his mother to buy

Seurat's *Invitation to the Sideshow* (*La Parade*), now at the Metropolitan Museum of Art in New York, for essentially the same amount of money.

The other objects in his parents' collection were less distinguished as a group, with the exception of their seventeenth- and eighteenth-century English furniture, the latter of which forms the core of the Museum's holdings in this area.[3] Some of these pieces now furnish the Rococo drawing room from the London townhouse Tower Hill, which was given by the McIlhennys in 1922.

John McIlhenny had a strong sense of public responsibility about his collecting, and he often commented upon the positive actions of other collectors. On April 25, 1917, he wrote to the *Public Ledger* about the will of John G. Johnson, who at his death earlier that month had left his entire collection of European painting to the city of Philadelphia:

> *His collection may possibly be best described by saying that it is representative, scientific, and intellectual and most of all that the pictures possess character and charm, the latter that intangible and ineffable quality which causes works of art to give genuine pleasure, exhilaration, and satisfaction to the soul. The pictures were, to Mr. Johnson, undoubtedly a great source of relaxation, of comfort, and of consolation. He has passed on to the City in which he lived an expression of his life, the effect of which upon our future culture and taste cannot now be measured. No art critic in any part of the world will hereafter consider his education complete without a visit to the Johnson collection.*

John D. McIlhenny was committed to the importance of public institutions for the greatest good. He spoke on the "commercial value of the art museum" in an interview in the *Public Ledger* on January 16, 1924, the year before he died:

> *The great art museums of a city are usually considered to be effective upon the cultural life of the community almost exclusively; but the fact remains that they do exercise a remarkable*

influence upon the commercial side of the city as well. It is true that virtually all of these museums are founded and maintained largely for their cultural effects upon the people, but this does not end their usefulness in their communities.

Philadelphia has made and is making a material contribution to the art of the country through its museums. Our own museum in Memorial Hall, in the Park, is doing all it can in the matter of contributing to the art life of the city, not only in a cultural and educational way, but it is of practical assistance to the craftsmen and manufacturers, who take advantage of its collections.

The present Museum building on Fairmount owes much of its existence, as well as some of its best works of art, to John D. McIlhenny's energy and perception. He died well before its opening in 1928, but with his successor Eli Kirk Price he established the political and physical plans for its construction.[4]

In 1922, as president of the Pennsylvania Museum and School of Industrial Art (later the Philadelphia Museum of Art), John D. McIlhenny was interviewed on his return from Europe concerning contemporary art in this country. "American taste . . . is at last on a firm basis," he noted proudly on September 20 in the *Public Ledger*, and with the surge of Americans traveling abroad and their considerable buying power, "the best are equal to the connoisseurs of Europe, and the best equipped of them are not to be impressed by meretricious works. The general run of pictures coming into the United States from Europe now are as good as, if not better than, the general run of pictures that find their way from European studios and galleries into European homes." In the formation of his own painting collection, however, he was only able to embody this assessment in a limited form. As his son often remarked, both his parents had a serious respect for professionals in the field of art—museum people and art historians and scholars—and by 1911 the senior McIlhennys were dependent almost exclusively on the advice of William R. Valentiner for their purchases of old masters. Valentiner, who had advised John G. Johnson and would have a long and distinguished American museum career, unfortunately led them to rather

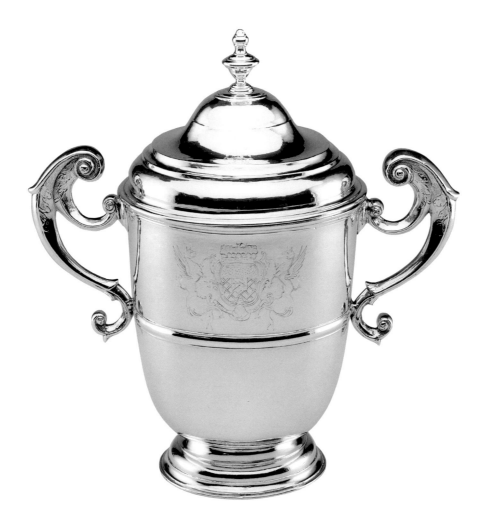

Two-handled silver cup with cover, 1706, by the
Irish silversmith David King (freeman 1690, died
1737). Height 13″

weak purchases, prompting Henry McIlhenny to repeat more than
once his irritation at the opportunity missed.[5] These observations are
supported by the fact that few of the pictures were deemed important
enough to stay with the collection when the John D. McIlhenny
bequest was received by the Museum.

 John D. McIlhenny's will, issued on August 10, 1925, with an
attached memorandum dated October 30, 1925, made specific be-
quests to his children and family, but almost all works of art of any
consequence were left to the Museum (although delaying any phys-
ical removal until after the death of his wife), whereby the Museum
could choose only those works it wanted. Henry McIlhenny's be-
quest, which essentially parallels that of his father, is perhaps the
strongest indication of how loyal and characteristically consistent he

was to his father's memory. John D. McIlhenny also left an endowment for the acquisition of works in his name, noting that "such purchases be of articles of only the highest quality."

Several works that went to McIlhenny by the terms of his father's will (he was given the contents of his father's bedroom, which contained mostly English furniture and Dutch seventeenth-century paintings) have now rejoined the Museum's collections through his son's bequest. These include a bracket clock in its original case (a rare survivor) by the most important seventeenth-century English maker, Thomas Tompion, purchased in London in 1924; a mid-nineteenth-century silver covered vegetable dish by the Parisian Odiot, whose fame dates back to the classical style of the First Empire, bought in Philadelphia in 1919; and a small landscape by the seventeenth-century painter Frans de Momper bought in London in 1911, which in his own assessment, was the only good object of the several Dutch works he had from his father. His father took a particular interest in eighteenth-century Irish silver, of which David King in Dublin was one of the most inventive craftsmen. In 1925 he bought in London a gilded-silver strawberry dish, remarkably modern in its elegant profile and absence of raised ornament, and in Dublin, a silver two-handled covered cup, which is more typical of Irish flamboyance in its decoration.

A beautiful Constable oil sketch is also part of the collection, inherited from that section of his father's entailed estate destined for Henry's older brother John, who died in 1935. This one item perhaps speaks more clearly than any to the individualistic aspects of John D. McIlhenny as a painting collector. When he began buying pictures, the great vogue, practiced with particular extravagance by other Philadelphia collectors, was for eighteenth-century English pictures in the grand, Augustan manner. McIlhenny paid little heed to this taste, often associated in American collecting with a pursuit for ancestors, and chose to buy on a more modest level, much in the progressive spirit of his friend John G. Johnson.

Henry's mother, Frances Plumer McIlhenny, was by temperament and background quite different from her husband. She was better educated and, as Henry often noted, she shared completely in

her husband's enthusiasm for works of art and actively participated in nearly every purchase, both at home and abroad.

The household traveled frequently, and among the family papers is a passport, issued May 23, 1921, made out for the British Isles and France. It is issued to both senior McIlhennys, Henry (age ten), and —to judge from the photograph—a rather formidable maid, Louise May Eakle; his sister Bernice (Bonnie) was then of the age to have her own passport. In a letter from London to relatives in Germantown, Frances is wonderfully revealing about both herself and her young son Henry:

> *You will laugh when I tell you that J.D. and I take our breakfast in our room most luxuriously, he in his new brown wrapper & I in my giddy blue. . . . We rest after breakfast & start on our way briskly at 10:15. As Henry urged you must have a fixed hour. He is killing and adores sightseeing [and] is interested in everything tho leans to jewelry & costumes. John D. & I are keen on rugs & wood & Bonny sculpture & early Greek & Egyptian. Fortunately no one likes armor so we can skip that. . . . I enjoy every minute & have not been so happy for years. . . . Yesterday we went to the Kensington Museum which has such treasures & such quantities that it makes you dizzy. We saw the Ardebel carpet the greatest in the world. . . . The Landseer pictures are still stored to Henry's disappointment. That boy knows all the artists & sculptors as well as pleasing incidents which he relates to us. That Friends School is a wonder & of course he has heard art ever since he was born, tho he took it in more than Bonny who is slightly bored except historical things where she is the most alert of the party. Dates & ancient & all histories are her long suits. She knew as much as Hi [Henry] & seemed his equal in Latin. Mentally they are absolutely congenial.*

The letter goes on gaily for eight more pages in the same enthusiastic vein, full of news about concerts heard and theater seen and suggests, in its candor, gentle innocence, and good common sense, the stuff of a Jamesian character. While many remember

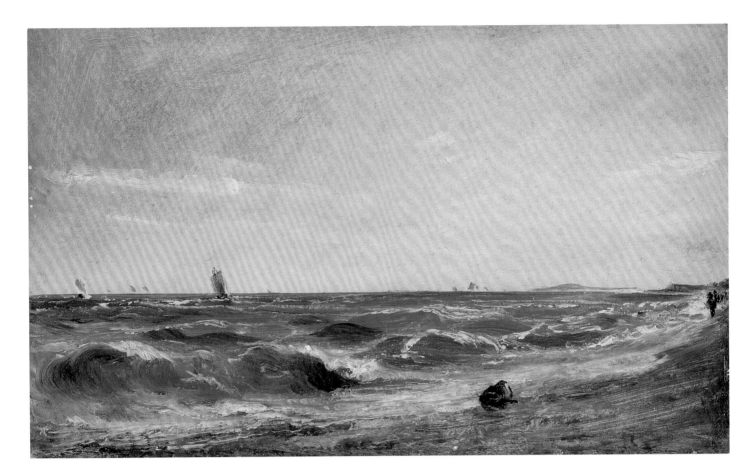

John Constable
English, 1776–1837
Coast Scene at Brighton, c. 1824–28
Oil on paper, 10 x 16⅝″

Frances McIlhenny's considerable reserve, her warmth and charm, witnessed by this letter, are abundantly evident.

After her husband's death, Frances continued to travel and buy works of art, although never on the scale of her husband. She loved English and Irish silver—something Henry would search out for her in his own independent travels—and acquired, among other pieces, an English mug by Job Hanks of 1700 and a grandly opulent cake basket of 1759 by William Plummer, both purchased in London in 1931 on the same day and from the same dealer, William Comyns & Sons; and, most important of all, two late-seventeenth-century gilded-silver toilet caskets by Thomas Bolton of Dublin, purchased in London from How of Edinburgh in 1936. She also enjoyed eighteenth-century French furniture and bought good, if not grandly impressive, objects, as much for use as part of a seriously formed collection. She also collected eighteenth-century English porcelain— Worcester and Chelsea—some of which McIlhenny kept after her death, although it was never a major interest of his.[6] By the early 1930s, when he began to draw his mother into a much bolder level of collecting, it became nearly impossible to distinguish Frances's taste from her son's.

Strawberry dish of gilded silver, 1712–14, by the Irish silversmith David King (freeman 1690, died 1737). Diameter 9″

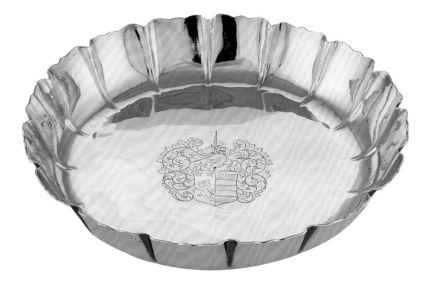

Toilet casket of gilded silver, 1699, one of a pair
by the Irish silversmith Thomas Bolton (freeman
1686, died 1736). Length 10½″

As McIlhenny explained in his Museum lecture, his parents'
collection was the result of "a dated eclectic taste . . . not ours today
at all; and the Museum wisely selected only the best things, which
would have pleased my parents who valued quality and respected
the judgment of professional museum people." This professional
element was what McIlhenny would add to their collecting activity,
and as well schooled and enthusiastic as he was as a boy, it was at
Harvard that the full crystallization of his taste and discipline as a
collector took place. He became, essentially, the professional that his
parents so much respected.

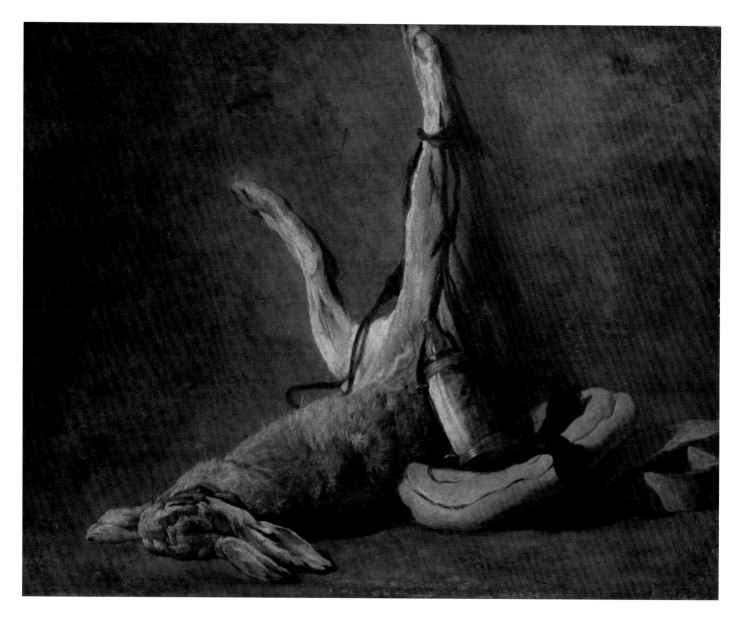

Jean–Baptiste–Siméon Chardin
French, 1699–1779
The Hare, c. 1730
Oil on canvas, 25⅝ x 32″

THE YOUNG COLLECTOR
1929–1934

H ENRY MCILHENNY ENTERED HARVARD IN THE FALL OF 1929, graduating in 1933 with high honors and staying on another year for graduate studies; he majored in fine arts. His era at Harvard has become legendary. Many of the men who would create the greatest collections of their generation and head the most important art institutions were there together: Joseph Pulitzer, the St. Louis collector and patron; Perry Rathbone, director of the Museum of Fine Arts in Boston; John S. Newberry, collector and print curator in Detroit; Lincoln Kirstein, a founder of the New York City Ballet; Charles C. Cunningham, director of the Wadsworth Atheneum in Hartford and The Art Institute of Chicago; Theodore Rousseau, curator of paintings at the Metropolitan Museum of Art; and John S. Thacher, director of Dumbarton Oaks in Washington, D.C. Young men whose fortunes or spirits had survived the Depression, they created in those early years of the 1930s a new, professional attitude about art more sober and disciplined than that of their parents' generation. They wholeheartedly took up a new definition of what was most important in the history of Western European and American art and, in doing so, they laid the foundation of attitudes toward modernism that continue today to guide many of our art institutions.

The man who served as their most influential teacher was Paul J. Sachs, whom his students—most of all McIlhenny—always credited with their education as collectors. He built their ambitions and gave them the principles by which to practice their pursuit of beautiful things. Sachs, as has often been said, was as brilliant a connoisseur of the potential collector as of the works of art he himself so avidly sought. Intelligence, taste, flair, and the wherewithall to act

on one's enthusiasms were the keys to entry into the fine-arts circle that would gather, famously, at Sachs's Friday noon lecture at the Fogg Art Museum, and, even more importantly, at the weekly three-hour informal discussion of connoisseurship at his house, Shady Hill (which had belonged to Charles Eliot Norton before him). Sachs used his own rich collection as the textbook for this part of the noted museum course, and after Parkgate in Germantown, Sachs's house must have seemed to McIlhenny a wonderful oasis of lightly achieved precision and discipline, all generously shared by the small and rather formal professor who would never tire of quoting the prideful statement of the Goncourt brothers: "If our collection was to be destroyed by flames, there would be a lacuna in the history of art."[7] In the case of so many in the group, he need hardly have said, "Go and do likewise." Sachs's other favorite quote was from the Dutch scholar Frits Lugt speaking of the collector's world: "It is in so many ways a world apart into which the new initiates, alerted by a touch of genius, are welcomed with the best grace, with an encouraging smile or a knowing wink. Sensibility is the first condition of entry into this milieu; intelligence only a reference."[8] And Sachs conveyed his profound sense of quality in works of art through the study of drawings. He traced the grand French tradition using the Fogg's collection and his own, from David, Ingres, and Degas through Cézanne and Matisse, which for McIlhenny established a standard from which he never fundamentally veered. But perhaps more than a literal thing taught, Sachs provided the entry of fortunate young men into Lugt's "world apart" through numerous trips to museums, scholars, dealers, and, above all else, collectors.

McIlhenny's letters to his mother trace his progress at Harvard, and they show the development of the special relationship of mother and son as collectors. In the fall of 1930, he wrote to her:

> *Saturday morning I went to French and we had the first lecture which was a brief review of early French history and rather boring. The History of French Painting followed and Sachs was terrifying. He assumes that we know everything. His nephew who is in my entry and is very nice says that Professor Sachs is*

a slave driver and that expecting us to know the name of every place and what not is a pose. Nevertheless, the lecture was splendid—a review of Romanesque architecture and sculpture in preparation for the next class on Romanesque painting.

Whatever terror he felt, he applied himself to a rigorous curriculum and continued to report details of his studies to his mother. In 1932 he wrote:

> *All Thursday I studied for my examination, and on Friday at twelve we had to identify seven slides and (2) enumerate and briefly describe the political events and conditions in Italian history of the 12th century that illustrate the sense of continuity with the ancient Roman past, (3) on the basis of your collateral reading, discuss education in Italy during the Dark and Middle Ages. As you can see, that is quite a lot to answer in one hour. I knew the slides perfectly, but the rest of the examination was very broad and difficult, as there is so much to say. In a Fine Arts course it does seem silly.*

Despite this, "the examination papers were returned and per usual, which sounds awfully conceited but is true, I did very well. In Venetian Painting, A, and 86 or B in Art and Culture of Italy were both entirely satisfactory."

In turn, McIlhenny took his mother's education in hand, sometimes with an aggression that would seem almost brutal unless one understood the mutual accord behind every acquisition. By 1933, when he was back in Cambridge as a graduate student, he could write bluntly:

> *Without courage no great collections are formed. Sachs (and I, in modesty) have knowledge of the 19th century and in that period only can a great group of works of art be still collected within a possible price range. Your own second-rate collection of pictures must not be repeated. It was not your fault, as it was Valentiner's, but I do not want to repeat the process.*

By this time she had shown her support for him in forming a collection that already in his rooms in Harvard's Dunster House or at Parkgate would be the envy of any serious collector of nineteenth-century art, regardless of age or position. By his sophomore year he had purchased from Wildenstein & Co. in New York Chardin's still life of a hung hare, game bag, and powder horn, which is one of the artist's most economically direct and deceptively simple paintings. When shown in 1979 in the monographic exhibition in Paris, this painting was cited as "the most accomplished among Chardin's still lifes with game."[9] As McIlhenny's first major purchase, it would later be seen as atypical for the collector—his only important French eighteenth-century painting—but qualitatively it set a standard.

In 1931 he and his mother purchased from Jacques Seligmann in Paris, Toulouse-Lautrec's *At the Moulin Rouge: The Dance*. The large canvas shows the immense dance hall in Montmartre that had opened in 1889, with its can-can dancers and clientele who were often no less exotic and extraordinary than its performers. Toulouse-Lautrec frequently portrayed the night life of this sulfurously lit emporium and chose it as the scene of this painting, which is arguably the most ambitious picture of his career. Valentin Le Désossé—an amateur of remarkable physical fluidity on the dance floor—with his partner La Goulue, casts a spill of green shadows. Jane Avril, her knee beribboned, joins in the dance, and Lautrec's friends line the bar. After showing the picture at the Salon des Indépendants in 1890, Lautrec lent it back to M Zidler, owner of the dance hall, and it remained with him until 1893.

Henri Matisse's study for *The White Plumes* showing a model wearing a hat of his own invention was bought from the artist's son in 1932; it was joined that same year by Seurat's black crayon drawing of a trombone player as a direct gift from his mother, for which he thanked her in a note: "The Seurat arrived yesterday and it really is an amazing thing, and I couldn't be more thrilled or happier to possess it."

In 1933 McIlhenny bought the mysterious *Standing Female Nude* by Corot, which may have been a rare occasion when he was reflecting his father's taste. John D. McIlhenny had owned a particularly

OVERLEAF
Henri de Toulouse-Lautrec
French, 1864–1901
At the Moulin Rouge: The Dance, 1890
Oil on canvas, 45½ x 59″

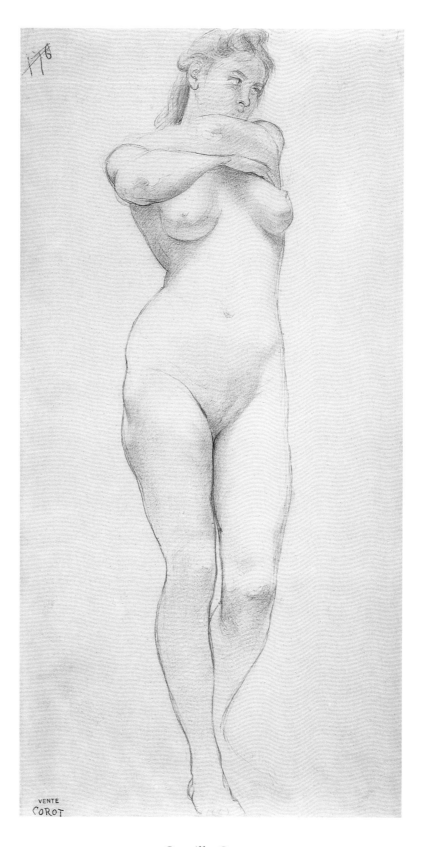

Camille Corot
French, 1796–1875
Standing Female Nude, c. 1845–50
Graphite on cream wove paper, 18⅜ x 9⁵⁄₁₆″

28

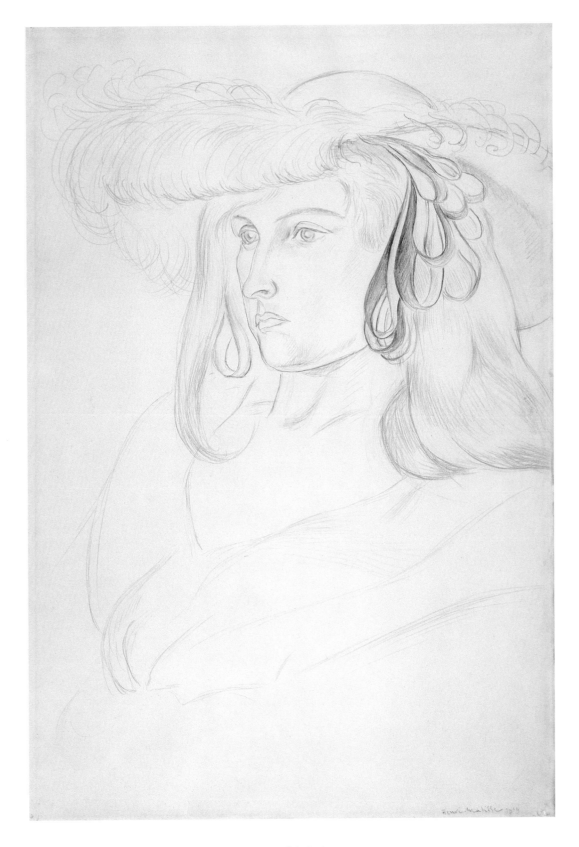

Henri Matisse
French, 1869–1954
Study for *The White Plumes*, 1919
Graphite on white wove paper, 21³⁄₁₆ x 14³⁄₈″

29

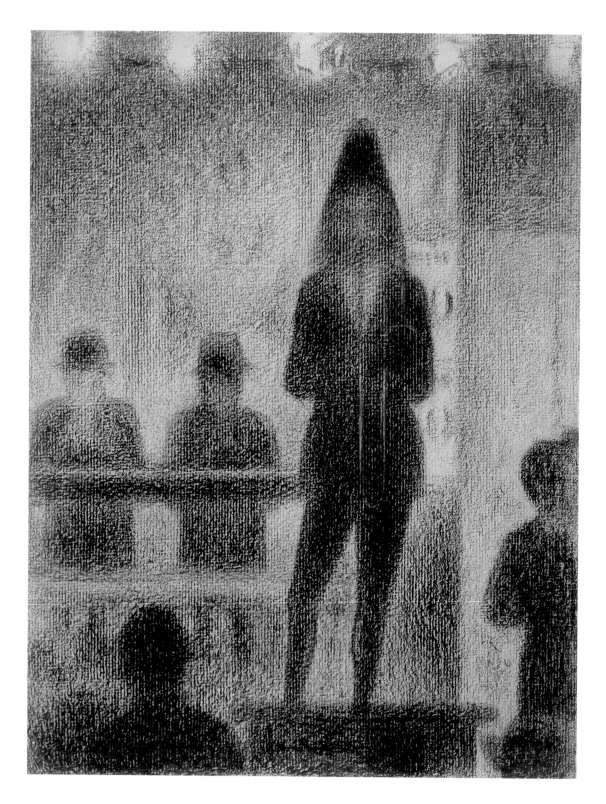

Georges Seurat
French, 1859–1891
The Trombone Player, c. 1887–88
Black crayon with white chalk on off-white laid paper, 12¼ x 9⅜"

fine Corot figure piece. With all these treasures adorning the walls of a college room, it was no wonder he would write his mother in 1932 that his tutor Mr. Niver "liked my things, although his speciality is Romanesque manuscripts and that sort of thing and his weakest period is the nineteenth century." When the loan of his Matisse drawing to a show in Dunster House was announced in the Harvard *Crimson*, he could only note his embarrassment and amusement. In this amazing accrual, he had his mother's full financial and emotional support but Sachs's hand remained ever present. The Corot, in fact, was a drawing originally sent to the Fogg on Sachs's recommendation as a purchase either for himself or the museum; when this did not work out, it was Sachs's assistant Agnes Mongan who alerted McIlhenny of its presence in the building. A Cézanne watercolor of *Mont Sainte-Victoire* was bought (after his college days) indirectly from Sachs; McIlhenny gave it back to Harvard in 1957 in honor of his professor.

In the summer of 1933, following graduation and before his brief return to Harvard for graduate work, McIlhenny came completely into his own as a collector. Confident in a fashion that he would never abandon, he entered into the art life of England and France with an energy and high appetite that would have been remarkable for any man. He was twenty-two.

He went to Europe for about four weeks with two Harvard friends and returned at the beginning of September. It was a trip he often spoke of later, his first without his family. A set of letters to his mother survives. From the R.M.S. *Berengaria*: "Now that I've made the break, I am excited about being in Europe. . . . The only mar is the fact that you couldn't come too. It is a disappointment, but of course you decided the only sane and sensible way—a year from this September we must get off to Italy." London was museums, private collections, and dealers. "It is thrilling to actually see the things I've been studying"—boxes of Watteau drawings at the British Museum, Chinese objects with the Eumophopoias family on the Chelsea embankment, which were "the most marvelous . . . things you can possibly imagine," and modern sculpture as well, a "lovely Mestrovic Madonna. . . . I learned a lot."

"I went to all the dealers you can possibly imagine!," he reported, among them, Knoedler, Colnaghi, Durlacher, Colswell, and Tomas Harris. Then he pressed on to modern dealers and bought a sculpture by the young Maurice Lambert. At Tomas Harris he was particularly taken by a large Tintoretto, a Madonna with members of the Cornaro family. He returned to look at it the next day and wrote to his mother that despite its size and inappropriateness for a private collection, "someday you must buy a great painting of any school or period, and you will have to be willing to pay the price of the Marquand rug, if not a bit more." A few days later he wrote to her again:

> *We went to every good silver store in London. . . . How of Edinburgh, who has a very swank place on Berkeley square, had tip-top things, but nothing we needed. I found your present at Burfitt on Albemarle Street, and they are something that we haven't got at all in Philadelphia, and Dr. Woodhouse says that they are without doubt the finest that he has ever seen or heard of, and awfully rare. I do hope you'll like them, but in any case they are grade A things. . . . At Mallett I bought a perfectly beautiful Vincennes bowl, 1753 (that is the same as Sèvres but earlier), a lovely blue green paste with gold ornament and in the cartouches are cupids. My description isn't good, but the bowl is grand, and of finest quality. I know you would have gotten it, so did not hesitate.*

Langton Douglas, the dealer and scholar of Renaissance art who remembered John D. McIlhenny well, had the "best [things] in London. . . . A very early Peter Breughel of St. Michael killing the dragon, . . . a delightful Sienese genre scene that I love, and a splendid school of Duccio adoration with those grand medieval horses at one side. The things intoxicated me with delight, and I want them all! I only wish for you, as you would fall in love with them too." Cables were exchanged, her reply being that she disliked Breughel. This led the following day to a furious letter, reciting art history and deriding her for buying French and English furniture, Chelsea porcelain, and

the like. "This is ART whereas the other things are merely 'art deco-ratif.'" This culminated in a stormy defense of his judgment about works of art: "I have bought things in the past well and wisely, and regret nothing. . . . What do you regret?" However, even a special mailing off of "the big Breugel book by Gluck" was to no avail, but by the end of the letter the seas had subsided: "I am crossing the channel tomorrow on the *Golden Arrow*. . . . Maybe it's better to wait until I've seen the things in Paris before buying anything here."[10]

By the time McIlhenny had reached France, having sat near the duke of Marlborough on the boat ("I was entertained to watch so notorious a person. On the surface he really looked all right."), his ire had subsided. McIlhenny was apologetic, but his first letter from Paris to his mother at their summer house in Prout's Neck, Maine, still ends: "It means everything to me to see works of art, and of course the desire to collect consumes me with a raging fire. You must not let your passion for it subside washed by Maine waters. . . . A faint heart gets you nowhere."

If there was often a tone of petulance in his demands, it was tempered by the frequency of their exchanges testifying to their intimacy and his determination that she join him in his now com-pletely formed ambition to be a great collector. From the Lancaster Hotel in Paris he wrote on August 26: "Yesterday morning I met de Hauke at Morgan's to pay for the Renoir. The sum will shock you, so I'll let it wait until I return." The object he referred to was the exquisite drawing done after the canvas *Dance at Bougival* (now in the Museum of Fine Arts, Boston). Made to illustrate a story in the magazine *La Vie Moderne*, this drawing reduced the huge picture to black and white without any loss of vitality or animation. César de Hauke, an agent for Seligmann in New York and Paris, had picked McIlhenny up after he had had supper at Le Cheval Pie and drove him to see the drawing, as McIlhenny recounted in his letter of August 23:

> *It was owned by a nice old Russian who used to be a rich oil man, but who is gradually selling all his possessions. . . . The enchanting Renoir is now on my bureau, and I love it. The whole*

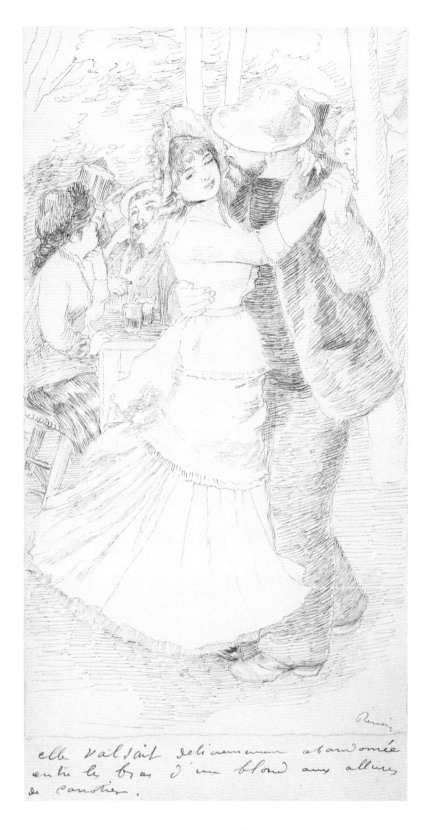

Pierre-Auguste Renoir
French, 1841–1919
Dancing Couple: Dance at Bougival, 1883
Pen and ink with crayon on white wove paper, 11¹⁵⁄₁₆ x 7⁹⁄₁₆″

thing is adorable, and so French, especially the legend 'elle valsait délicieusement abandonée entre les bras d'un blond aux allures de canotier' ["She waltzes with delicious abandon in the arms of a blond who has the allure of an oarsman"]. I hope you realize its great rarity, as I know of but one other pen and ink by Renoir and that is John Nicholas Brown's.[11] The technique is amazingly delicate and the photograph makes it appear much too harsh . . . this is a high water mark in my collection. . . . It is too delicately done to be hung and will have to stand on a table or easel, so that it can be examined closely. I couldn't be more delighted.

He found a Louis XVI frame for the Renoir: "The mat is pale pink and blue, and the frame gilt—which sounds wet but will be *perfect* for the drawing." His rapture was no doubt heightened by the Renoir exhibition he had visited early that week at the Orangerie: "I was thrilled to see the pictures and drawings that I know so well in black and white. Renoir was a grand painter, and for pure charm and lusciousness no one else in the 19th century can touch him."[12]

In his letter of August 26 to his mother he reported a second meeting with de Hauke:

> *He also had a great disappointment in store for me, as the man who owns the wonderful Degas has decided not to sell. Apparently he is an extremely difficult person, and impossible to deal with. De Hauke, naturally, is equally irritated, as he loses the commission. He went out to see him in the country and he thought he had the drawing, when the man's sister came in and advised him not to part with it. Consequently a masterpiece has slipped through my fingers. The dealer still has hopes, and will try until he can get it for me. The only thing is to wait. I must have that Degas!!!*

The drawing was *The Ballet Master* of 1875, showing the great Jules Perrot in retirement, gently leaning on his baton with which he beat the time; Degas used the figure in three of his most accomplished ballet pictures. McIlhenny recalled seeing it "in that

Edgar Degas
French, 1834–1917
The Ballet Master, 1875
Oil on brown wove paper, 18¹⁵⁄₁₆ x 11¹⁵⁄₁₆"

group of facsimiles which Sachs went over in detail one night I was there for dinner. I remember distinctly his anger at not having bought it when he had the chance because he considers it one of the top-notch drawings." The drawing did not come easily to McIlhenny, but his patience and persistence won out: De Hauke's receipt from New York for this work is dated November 10, 1933.

At Jacques Seligmann he saw a Delacroix portrait of the school-boy Eugène Berny d'Ouville. It is one of possibly ten portraits of students commissioned between 1824 and 1830 by Delacroix's friend Prosper Parfait Goubaux, who was principal of a secondary school, to commemorate their special academic achievements. Since the portraits hung for twenty years in one of the schoolrooms, it is perhaps not surprising that only three are known to have survived.

> *It is perfectly beautifully painted, and in perfect mint condition. The face is extremely sensitive, and terribly Romantic in the best way. It is an oval canvas, rather small, and the coloring is soft but fresh. It is quite well known, having belonged to Degas, who had marvellous taste, and also Dr. George Viau, a famous collector. It has been in all the exhibitions, such as "Romantic Youth" and so forth and, most important of all, in the big Delacroix show at the Louvre some years ago. As you see, it has a long and honorable pedigree and it is just the type of Delacroix that I want for my collection of 19th century French painting. . . . You would love this picture, and it would be grand anywhere in our house, either downstairs or up. I feel sure you would approve.*

He returned to the subject three days later on August 24 in a letter to his mother. Having exhausted his own bank account, he issued a new request for support: "The Delacroix, the Degas, and the Renoir would be an astounding bag for one year and I am perfectly sure of myself in all three things." A cable was sent; the bill for the Delacroix is dated August 26.

McIlhenny's visits to museums produced mixed reviews: "The Luxembourg . . . is so dreadful, and the Cluny . . . is old-fashioned

and comfortable." Rodin "does not thrill me particularly"; much of the Louvre was closed, to McIlhenny's great irritation, particularly because he could not see the Manets in the Caillebotte collection, but the Moreau-Nelaton collection of nineteenth-century French paintings, then housed in the Musée des Arts Décoratifs, more than made up for it.

Modern art dealers were also on the agenda, both for himself and for his sister, where he could find "cheap modern paintings by artists of promise." This was clearly new territory for him: "Léonce Rosenberg was most entertaining, as he has nothing but cubistic and other outre pictures. They are so ghastly yet fascinating." Dudensing had a "fine early blue Picasso, but for some reason I wasn't thrilled." He was taken by, and he bought for his sister, a painting by Derain of a woman holding a fan and a "fascinating little Picasso abstraction in gouache which I think is extremely nice." Bignou had an "amazing huge Rousseau jungle picture . . . [and] a nude of Rousseau's wife," which were enchanting but not the stuff to act on; however, at Pierre Colle he got for Bonnie a "charming Lurçat, very brilliant in coloring [and] . . . for myself I acquired an interesting surréaliste work by Salvador Dali. The title is 'Gala et l'Angelus de Millet précédent immédiatement la venue des anamorphes coniques.' Its meaning is incomprehensible, but it is beautifully painted, like a primitive in its minuteness. Tiny, and in a black velvet box frame it's very striking and fascinating." (The latter, which McIlhenny sold in 1974 and is now in the National Gallery of Canada, is one of the masterpieces of Surrealism.) "De Hauke got a lot of poor little moderns together . . . [including a] large de Chirico, which will do for Bonny's studio . . . and it really is a bargain, and very stunning if well framed." McIlhenny paid the equivalent of about forty-five dollars for the work. He had bought four pictures for his sister in one afternoon and did have to admit: "Buying for other people is very difficult, but I loved selecting."

He was also very impressed by a group of works by Joan Miró seen with Pierre Matisse: "They are surréaliste, very large, and very cheap. Of course they are very advanced and difficult to understand. Some day soon I shall order four large ones to panel a small room."

Eugène Delacroix
French, 1798–1863
Eugène Berny d'Ouville, 1828
Oil on canvas, 24 x 19⁵⁄₁₆″

He visited Pierre Matisse at his home on the rue César Franck and saw Matisses that he thought his sister should take seriously when they would be shown in New York that winter. Some time that year he acquired from Valentine Dudensing, Henri Matisse's lyrical *Still Life on Table* of 1925. He always kept this painting in his dining room, where he enjoyed observing that the pineapple is almost certainly candied, since it is so carefully set in a straw box, surrounded by pink excelsior.

Somehow, through all this, there was time for a day at Chartres, going out in an open Citroën, wonderful meals (sometimes described in loving detail), and visits to relatives. There would be many other trips abroad but perhaps none so heady. It was his first step into the market on his own and, as he often recalled about shopping for pictures in the 1930s, there was a great deal available with very few buyers. He complained jokingly in his letter of August 24 of trying to sleep late only to have the dealers begin calling: "I feel exactly like a carcass mutilated by vultures." But in recounting his expenditures, which were considerably beyond his expectations, he did confess to his mother: "The only thing I dread is the letter of credit, because there won't be much left. I have an account of everything. London seemed frightfully expensive. I have bought a lot, of course, when you consider the Delacroix, the Renoir, the silver, the Sèvres, my clothes, and then Mrs. Keith's money [an ex-nanny of the family whom he had visited in England]." But—as he demonstrated so often throughout his life—spirits rallied quickly and he continued: "I am perfectly sure of all my purchases, however, and feel entirely justified. Spending so much completely by myself and deciding on pictures, drawings, and so on is a little scary, I must confess. At any rate, I've done the very best I could and know you would have done the same." Blithe spirits sustained; he closed his last letter with, "My next trip to Europe I may get myself painted by Bonnard or Vuillard. They are both excellent men, and very popular in France. Of course it wouldn't be flattering or a good likeness, but it would be a work of art."

On his return, he went back to Harvard for graduate studies, having noted earlier that "another year here is absolutely imperative

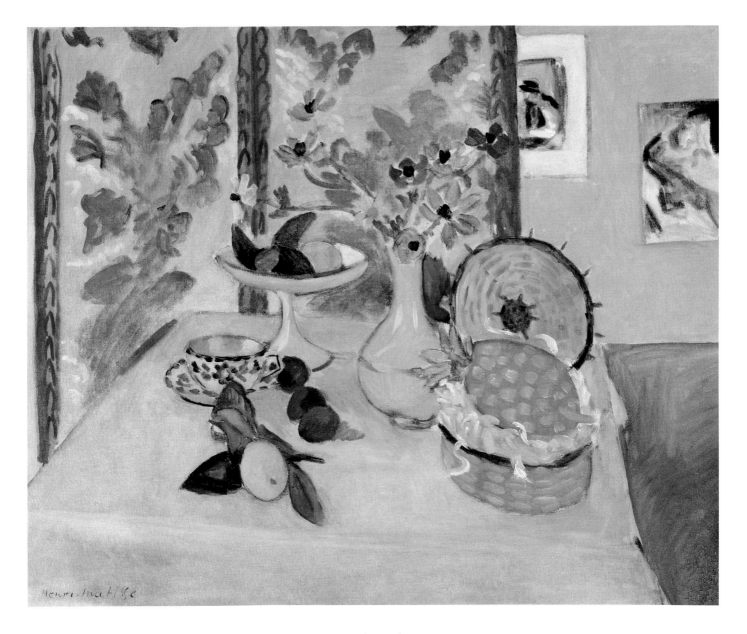

Henri Matisse
French, 1869–1954
Still Life on Table, 1925
Oil on canvas, 32 x 39½"

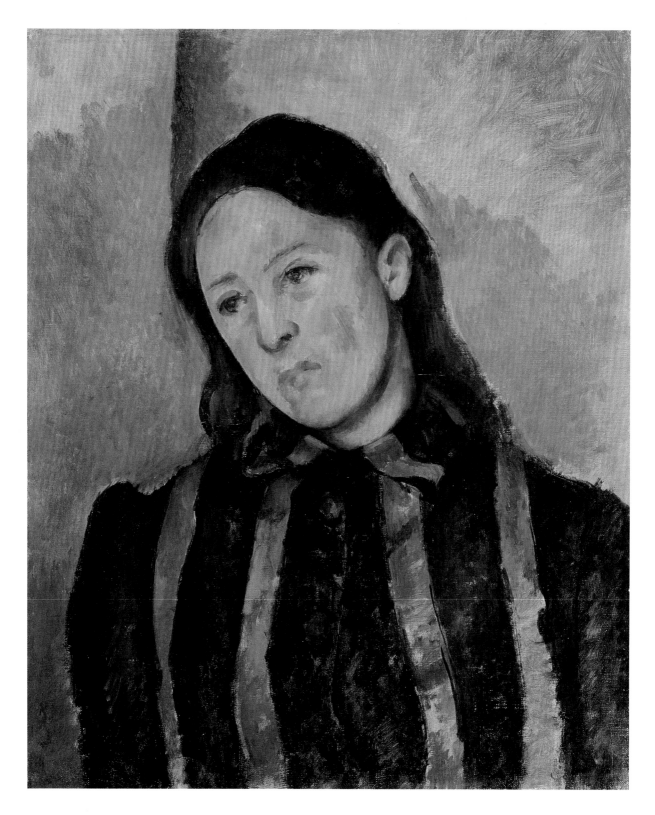

Paul Cézanne
French, 1839–1906
Mme Cézanne, 1890–92
Oil on canvas, 24⅜ x 20⅛″

so my bookcase will get more than three months usage. After that Europe is the thing, as one simply has to see the pictures." His mother accommodated his move to a charming Federal house on Carpenter Street in Cambridge by sending up his father's painting by Thomas Eakins, *The Zither Players*, now at the Museum. He saw Sachs frequently, and while he was by no means unique among his fellow students to receive his professor's full encouragement as a collector, he was in a position, with his mother's financial support, to act readily on purchases. This is perhaps nowhere more clearly evident than in a letter home in the fall of 1933:

> *Just emerging from the Fogg I ran into Sachs, with Paul Rosenberg, the dealer, and Sachs invited me for luncheon. He has just come back from an art tour in New York, so will be full of gossip. I'm anxious to ask him about Rosenberg's Renoir which is glorious. If he would come down a lot I feel it would be no mistake, whatever happens in Germany where nothing more apparently has developed. Quality is the arbiter in buying things.*
>
> *Lunch at the Sachs' was very pleasant, and extremely thrilling. Rosenberg had all of his coloured photographs, and the three of us went over them all, selecting the cream. Sachs knows every picture, of course, and is quite disinterested. He is keen, however, to have me form a truly great collection of 19th century French drawings and paintings. We chose first nine pictures and then asked the price, and only four are fairly and justly marked. I copy below the list, the checks (approval) and crosses (discard on account of price) are Sachs':*

		Thousands
X	*Ingres, Portrait of Mme Ingres*	75
X	*Renoir, Mlle Legrand (my favorite)*	60
✓	*Degas, very early beggarwoman*	18
✓	*Cézanne, Mme Cézanne*	35
X	*van Gogh, Street in St. Remy*	60
X	*van Gogh, Self-Portrait*	100
✓	*Delacroix, Sardanapalus*	42

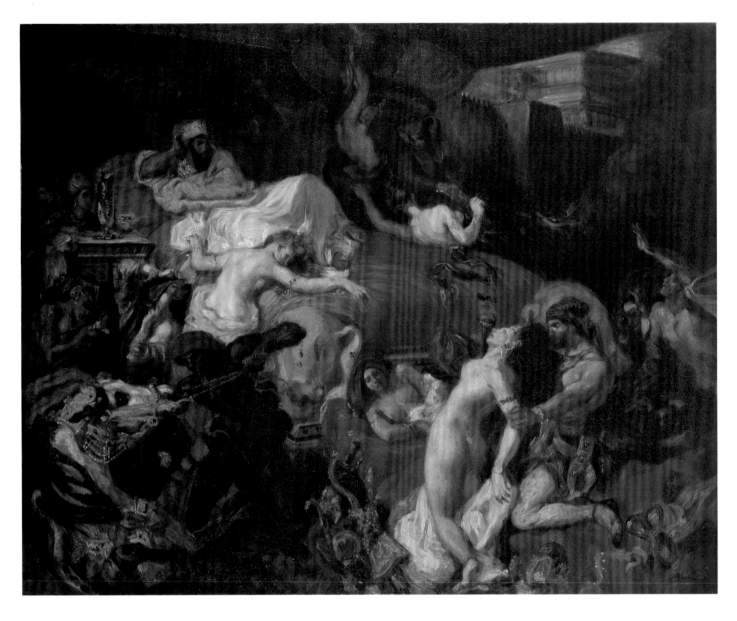

Eugène Delacroix
French, 1798–1863
The Death of Sardanapalus, 1844
Oil on canvas, 29 x 32⁷⁄₁₆″

Everyone is a great picture and Sachs advises not to wait for Germany, as it is too vague. The delicious Renoir is too high, and out of the question. The brilliant van Goghs, formerly in the Fuller Collection here so I know them intimately, are preposterous in value.

The Cézanne portrait, as I told you before is a masterpiece, and within our price range. Nothing better in quality by him exists, and it is very pleasing indeed, . . . a marvel.

The Delacroix is a sketch for the huge Louvre picture and of course is famous as among the artist's most important and greatest works. It illustrates the other side of the master, as my portrait is restrained and more classical.

The Manet is utterly charming, and you would adore it. The Cézanne and the Delacroix interest me most, of course, and I do feel that we simply must get one of them—Historically, the Sardanapalus is more interesting, and would complete Delacroix for me. The Cézanne is glorious, but perhaps not as much your taste as it is mine. Of course Rosenberg for cash will come down, but not much, so don't expect a huge slash. The difficulty is to choose. Both are equal in fine quality and strength. We can pay at leisure, Rosenberg says. Please think kindly towards all this. You cannot realize what an absorbing interest it is for me. A great Renoir you never will find at these prices: 30 or 40 thousand dollars.

The Cézanne is being sent on approval over Christmas, when we can carefully examine it and live with it constantly. There is no responsibility attached, and I know you will not object. It is being sent in my name, on my request. The Delacroix is still in Paris, but I'll have a photograph.

Don't get all upset over this, but be open minded, and keep calm. You certainly can afford either one, as I have 10 thousand in the bank, and you are willing and prepared to pay 30. Don't go back on your word—please!!!

She did not, of course. They bought the Delacroix—which McIlhenny by then understood to be the artist's 1844 reappraisal of his controversial masterpiece of 1827 depicting the suicide of the Assyrian ruler Sardanapalus—and the Cézanne portrait. By May 1935 *Mlle Legrand* was at Parkgate as well. Despite his desire to take time off to travel in Europe following his last year at Harvard, he returned to Philadelphia to live with his mother in Germantown—to continue their pursuit of great French works of art and to join the curatorial staff at the Philadelphia Museum of Art.

Pierre-Auguste Renoir
French, 1841–1919
Mlle Legrand, 1875
Oil on canvas, 32 x 23½″

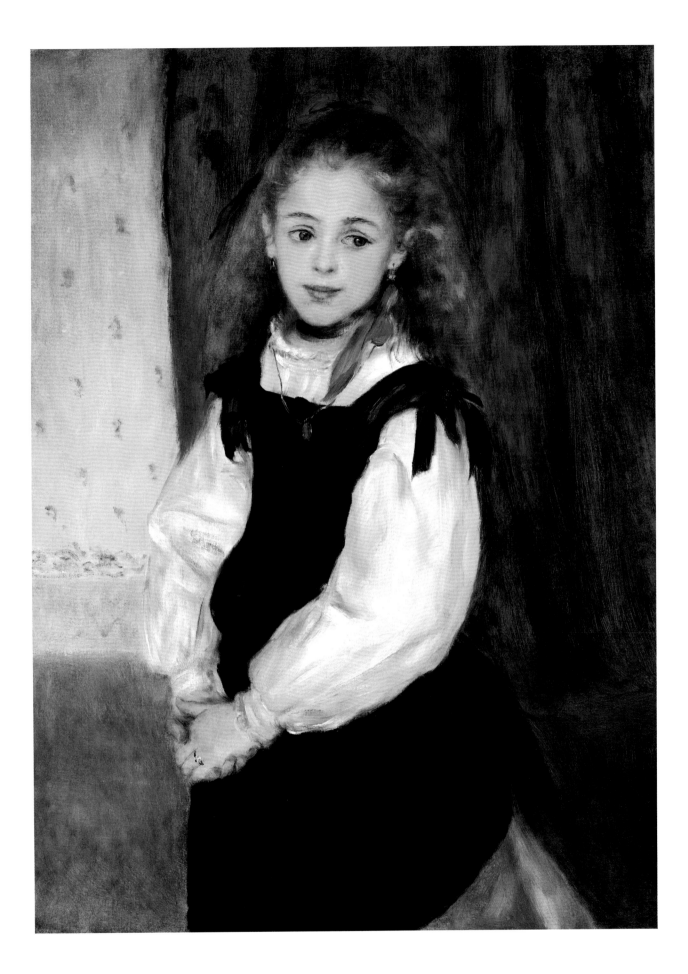

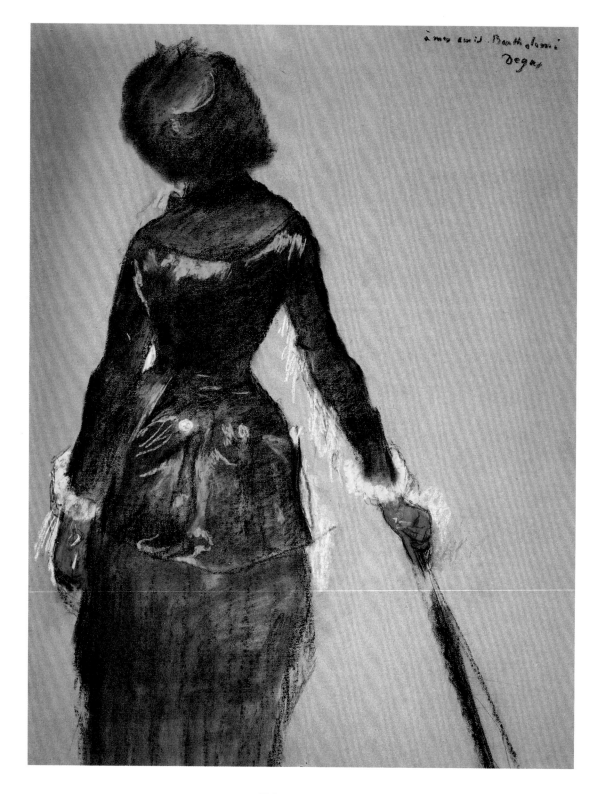

Edgar Degas
French, 1834–1917
Mary Cassatt at the Louvre, 1880
Pastel on gray wove paper, 25³⁄₁₆ x 19³⁄₁₆″

THE YOUNG CURATOR
1934–1946

❦

SPEAKING ABOUT HIS FATHER'S ROLE AS PRESIDENT OF THE Philadelphia Museum of Art, Henry McIlhenny recalled:

> *The Museum was a pretty pathetic place in those days, but he brought it out of obscurity and was responsible for the hiring of Fiske Kimball as director, truly an epoch-making move in the history of the Museum. . . . My father died almost at once after Fiske's arrival at the Museum, and I've always suspected he was shocked to death by Fiske's lack of manners, and brashness. Anyway, it was a great appointment.*

Fiske Kimball, in turn, never forgot John D. McIlhenny, and the appointment of his son as curator of decorative arts—assistant in December 1934 and curator by 1939—was governed by complex politics as well as common sense. Kimball's obligations to the family —Mrs. McIlhenny continued as an active board member until her death in 1943—were immense. It was clear from his formal but warm relationship with Henry McIlhenny throughout his tenure at the Museum that even as early as 1934 he was not merely encouraging and supporting a bright young member of his staff, he was cultivating a major collector.

McIlhenny's personal views were equally complex. Given his education and the early form that his own collection had taken, he would much have preferred to be in charge of the painting collections, a post then filled by Henri Marceau, who would succeed Kimball as director. However, it was all in all a happy fit and certainly a tremendously productive relationship for the Museum. The distinction between the departments of decorative arts and paintings was never

49

drawn too finely, at least for the organization of exhibitions, and during the 1930s McIlhenny was able to put together three successful shows of nineteenth-century artists: Degas, Daumier, and Blake. Along with this he installed the permanent galleries, wooed collectors, and pursued his own purchases, all within a schedule (then standard for the Museum's curatorial staff, or at least those who could afford it) of travel in Europe every summer. He enjoyed his professional duties immensely and as time went on, he came to understand his own purchases, nearly all of which were beyond the Museum's very small acquisition budget, in relation to the public collection and as something that would one day merge with it.

Kimball's thoughts on his future curator had already been evident in March 1934 while he was still sorting out John D. McIlhenny's estate, when he encouraged Henry McIlhenny to come and see the Museum "behind the scenes." The next month he wrote that he wanted to discuss his joining the staff of the Museum (albeit initially with no salary), which McIlhenny promptly accepted, although he did not actually begin his duties until Christmastime.

Life at the Museum was full of the routine tasks of a curator. Files are filled with McIlhenny's responses to standard inquiries and with detailed memoranda. He seems to have taken to it with true pleasure and to have thrived on the pace of the institution, which was rapidly growing into its new, vast spaces despite the restrictions of the Depression. In March 1935 he wrote his parents' old friend and mentor Mrs. Charles F. Williams requesting the move of some of her Oriental carpets from the permanent galleries for an exhibition of English oak furniture he was organizing to complement the furniture she and her husband had already given: "You will doubtless be surprised to have little Henry McIlhenny writing on behalf of the Museum." The next month he assisted guest curator William Macpherson Hornor on the exhibition "Authenticated Furniture of the Great Philadelphia Cabinet-Makers." If Fiske Kimball's attitude toward McIlhenny may seem to have taken an avuncular tone in discussing an offer of a suite of Victorian furniture from a trustee — "These things vanish into storage for the present, but, later, when they are more appreciated, we will be found in possession of some

fine stuff, acquired like this, by gift"—he was clearly given his head in most matters.

By 1936 McIlhenny had organized a major international painting exhibition: "Degas: 1834–1917." This show stands as one of the most important examinations of the artist ever undertaken; it comprised 105 works and met with international praise, catching the attention of a wide audience. Among the visitors were the art historian Kenneth Clark and his wife, with whom McIlhenny began a warm friendship that would span five decades. In preparation for the Degas exhibition, American museums and private collectors had carefully been approached for loans; in many cases, such as that of the Havemeyers, Lewisohns, and Harry Payne Bingham, McIlhenny was able to renew his acquaintance with New York collectors he had first visited as a student with Sachs's museum course. By the late spring loan negotiations became tense; just before going abroad to request French loans, McIlhenny learned that the Louvre was planning a major Degas exhibition at the same time. He, with the help of Kimball, argued the precedence of the Philadelphia show and shrewdly offered the Museum's exhibition as a gathering point for American loans to France if the Louvre would postpone its showing for three months. Henri Verne, director of the Musées de France, and Paul Jamot, curator of paintings at the Louvre, conceded, perhaps partly convinced by the promise for their show of one of Degas's most important early paintings, *Interior*, which McIlhenny and his mother had purchased in January of that year.

Paul Sachs had had the Degas painting (from the celebrated collection of A. A. Pope in Farmington, Connecticut) in his office for ten days prior to the McIlhenny coup of acquiring it and was heartbroken not to get it for Harvard. Learning of the acquisition, then entitled *The Rape (Le Viol)*, McIlhenny's Harvard friend Carl Pickhardty, Sachs's son-in-law, wrote:

> *It seems to me that you have made perhaps the most interesting acquisition that it will ever be your privilege to make. To me that picture is absolutely unique in the history of art because it is the only time that subject has ever been dealt with and by the only*

man who could possibly have done it. Whatever hopes you may
have in collecting and to whatever extent you intend to expand,
you have at least a unique collection which on its quality alone,
it seems to me, will fill a most impressive place. You certainly
have done yourself proud!

While the painting is no longer thought to be *The Rape*, the scene most likely depicts another, equally dramatic, moment, deriving from Emile Zola's novel *Thérèse Raquin*, when Thérèse and her lover first experience the full weight of their guilt for having murdered her husband.[13]

McIlhenny convinced Verne to lend eight critical works from the Louvre for the Philadelphia exhibition and even dislodged Degas's famous *Cotton Exchange, New Orleans* from the Musée des Beaux Arts in Pau. Paul Lemoisne made available his archive of 1,300 photographs, which would become the basis for Lemoisne's catalogue raisonné on the artist.[14] Private collectors and dealers were open and generous, the latter perhaps not too surprising given the young man's fame as an acquisitor.

McIlhenny's progress in Paris was enthusiastically reported to the women in his office, affectionately addressed as Stooges and Strainers (his own office nickname was Loveboat). More sober reports were sent to Kimball. He was also able to see the Cézanne show at the Orangerie in Paris that summer and to support with complete conviction the Museum's purchase of *Mont Sainte-Victoire* (which was already in Philadelphia when he left). He also saw and relayed his enthusiasm for one of Cézanne's *Large Bathers* from the Pellerin collection, which the Museum would buy the following year. Kimball wrote to confirm that McIlhenny's opinion of the Cézanne had been supported by the board of the Museum,[15] and shortly thereafter he was able to forward McIlhenny's first paycheck. "It makes my job seem much more definite and worthwhile," wrote the young curator in response.

McIlhenny's visits to private collections continued to prove particularly useful, both for his own education and for the Museum. During the summer of 1936 he visited in Boulogne-sur-Seine,

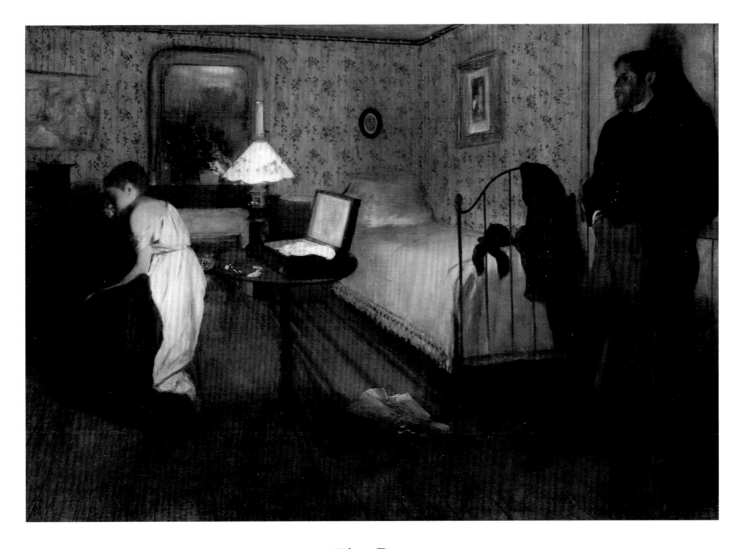

Edgar Degas
French, 1834–1917
Interior, 1868–69
Oil on canvas, 32 x 45″

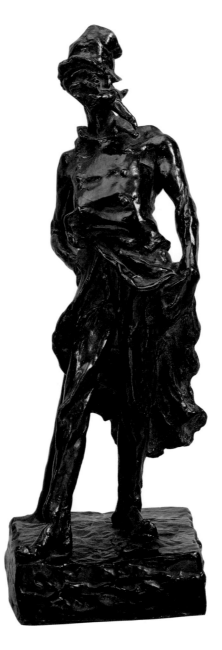

Ratapoil, by Honoré Daumier (French, 1808–1879), cast in bronze after a plaster executed in 1851. Height 17½″

Robert Esnault-Pelterie, whose collection contained fifteen paintings and watercolors by Honoré Daumier. Esnault-Pelterie discussed with McIlhenny his concern about the political events in Europe and that winter acted on the offer to send the entire collection, which he owned with his sister Mme Gaston Popelin, to Philadelphia for safe-keeping. The loan added great strength to the nine new French galleries that were opened at the Museum in March 1937; it included besides the Daumiers, five works by Corot (including one of his most monumental figure studies), five by Delacroix (with *Head of a*

54

Greek Woman transcending the group), four by Fantin-Latour, and six by Jean-François Millet. Negotiating the loan was a great feat of diplomacy and tact, and as McIlhenny noted in a letter to Sachs at Harvard, it also provided an enticing pool of potential acquisitions for the Museum. Before the final dispersal of the collection from Philadelphia in 1973, however, the Museum was able to buy only two pictures: Daumier's *Print Collector* and his *Imaginary Invalid*, both purchased in 1954 with the partial assistance of McIlhenny. Using Esnault-Pelterie's fifteen pictures as a core, McIlhenny opened the Museum's Daumier exhibition in November 1937. Like the Degas exhibition the year before, it was an event of major proportion. The catalogue is slim but contains a splendid essay by Claude Roger-Marx solicited by McIlhenny (printed in French only).

By summertime 1937 McIlhenny was back in Europe, and he cabled Kimball from London: "WILL YOU STORE GANGNAT COL-LECTION SIXTY LATE RENOIRS FOR SEVERAL YEARS MAXIMUM COST FIVE THOUSAND FRANCS SUGGEST EXHIBITION REPLY BERKELEY." Kimball answered in the affirmative, and this large, if mixed, group of pictures formed the core of the exhibition on Renoir's late period that McIlhenny organized in April 1938. Again, he sought and found assistance in Europe for his Renoir show. Paul Rosenberg and the young collector Douglas Cooper were fully praised for their help. "Renoir: Later Phases" was only a qualified success, however, in part because of the difficult nature of the material (the Gangnat collection was very much one of quantity) and the limits imposed on loans brought on by the approaching war. No catalogue was published, and perhaps the most lasting result to come out of the exhibition was McIlhenny's own commitment to the importance of this last, and still much debated, aspect of the artist's career. He purchased in December 1939, from Valentine Gallery in New York, Renoir's grand *Judgment of Paris*, a picture he sold in 1974 and now in Japan.

In 1938 Elizabeth Mongan, sister of McIlhenny's close friend and colleague Agnes Mongan, who had joined Sachs on the staff at the Fogg and contributed an essay to the Degas catalogue, came to Jenkintown as curator of the print collection being formed by Lessing

J. Rosenwald. The two of them decided to make use of Rosenwald's rich holdings for an exhibition in 1939 of William Blake manuscripts, watercolors, and prints. It was in many ways the most ambitious project McIlhenny undertook during his prewar career; drawing only from American collections, the two curators were able to gather and document in a catalogue, which stands as a basic reference on the artist, the most important exhibition of Blake's works in this country. The Philadelphia scholar and collector Edwin Wolf II was asked to participate; it was a happy and productive collaboration, of which McIlhenny was proud, although it was never one of his favorite achievements. The subject was not fundamental to his personal interests and the selection was so broad that the things he loved most—finding the objects, choosing the best, and landing the loans—were not as central to the endeavor as they had been earlier.

McIlhenny's own department of decorative arts, despite his involvement in major painting and print exhibitions, was not neglected. And if the frustration at the absence of any acquisition funds was often mighty, the pursuit of gifts and loans, particularly of American objects, was constant, and the installation of new material in Kimball's rapidly expanding Museum was ongoing. In 1939 he proudly announced to Sachs the preparations for the transferral to the Museum of Mrs. Alexander Hamilton Rice's collection of eighteenth-century furniture, tapestries, and Sèvres porcelain. "The Rice ballroom is practically finished," he wrote, "and we expect the material in about a month. Needless to say, I can hardly wait to get my hands on it." The ballroom, brought intact from New York to house the collection, had been made by the French decorator Carlhian,[16] a man whom McIlhenny knew well and from whom he had borrowed a diverse group of French scenic wallpaper for an exhibition he assisted on in 1937. He also worked on the installation of the newly received collection of glass from George H. Lorimer in 1938 (which was reinstalled by McIlhenny in 1940); with Henri Marceau in setting up the American furniture and decorative arts bequeathed by R. Wistar Harvey in 1940; and, in more temporary quarters, on the installation of the gift of medieval woodwork from Mr. and Mrs. Roland L. Taylor that same year.

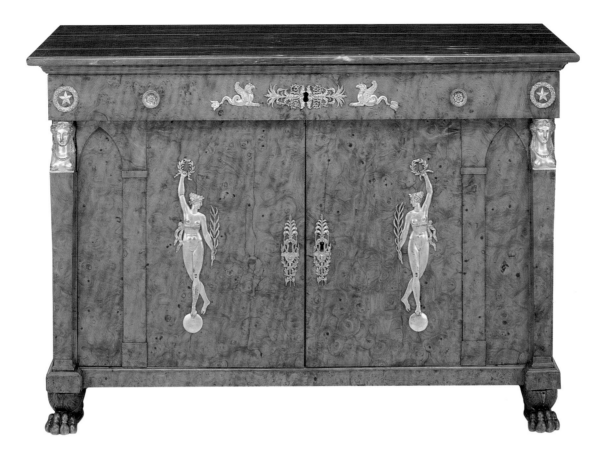

French burled-elm cabinet (*commode á vantaux*) with gilded-bronze mounts and marble top. Height 34¾″. Purchased in 1935, this was among the first pieces of Restoration furniture collected by McIlhenny.

The Museum was growing fast. The increase in staff was, of course, not without its disadvantages: In 1938 Mrs. McIlhenny firmly refused to support, as she had the exhibitions of Degas and Daumier, a Corot show that the director proposed to have organized by McIlhenny, Marceau, and David Rosen, the Museum's consulting conservator (the last two having contributed an important technical essay to the Daumier catalogue). "I really do not, having had two I feel someone else should. Anyway, I am very ambitious about Henry in the art world and unless he has an exhibition alone it would add nothing to his reputation so I would not be interested. Are not Mothers queer especially when they are frank?" This prompted a response from Kimball of exemplary tact, promising McIlhenny sole

responsibility for the exhibition. It would not be until 1946 that the exhibition was done, and then without McIlhenny's involvement. It should be noted that despite this refusal, Mrs. McIlhenny was always generous financially to the Museum and added several works of art to her husband's bequest, perhaps most important being a Renaissance bronze purchased from the Foulc collection. Her note to Kimball commenting on the Foulc catalogue revealed her own pleasure in collecting: "I know what fun he had from my own experience."

The loss of the Corot show in 1938 seems not to have dampened McIlhenny's spirits. From Paris that summer he wrote Kimball proposing another ambitious exhibition:

> *Several times I have suggested that some day the museum might put on a Second Empire show. I've discussed the idea with a number of people . . . Meyer Schapiro was very keen [at Columbia University]. . . . The show should cover all phases of the epoch: art, history, costume, literature, music, architecture, and so forth, each represented by outstanding examples . . . alongside of the academic artists like Winterhalter, Couture, Lami, and de Dreux, we should emphasize men like Guys, Monticelli, Carpeaux (paintings and sculpture), and the early works of the impressionists like Monet, Manet, and Pissarro. Courbet would be included, as well as Daumier, Gustave Dore, and so forth. A lot would have to be borrowed in Europe, but the insurance on most of the stuff would be low. In addition, I feel sure that I can find lots of material in America. 1850 to 1870 is a fascinating period, and to my knowledge, no show of the exact epoch has ever been held. Such a show could be made gay and attractive, and it would not be entirely frivolous.*

Kimball's reaction is unknown. The war intervened. One of those whom the scholar Meyer Schapiro and McIlhenny suggested assist them on the project was Siegfried Kracauer, who had just written a book on the French composer Jacques Offenbach. In 1940 Schapiro and McIlhenny fought valiantly through the red tape of United States immigration to assist Kracauer's escape to New York,

McIlhenny covering many of the costs. Such an exhibition eventually took place at the Museum in 1978, when McIlhenny was its chairman of the board, on a scale that met with his approval; his own earlier notions were unknown to the organizers when they proposed the exhibition, and it is perhaps typical of him that his ambitions of 1938 were never mentioned and were only discovered in the archives at that time.[17]

The late 1930s and early 1940s were difficult times for American museums. McIlhenny helped friends (many of them Harvard colleagues) gather masterpieces for the great art exhibition of the 1939 New York World's Fair, but his own professional activities were curtailed to essentially local affairs. He encouraged the Museum in 1942 to take, albeit in a reduced form, the Museum of Modern Art's exhibition of furniture and design organized by Eliot Noyes, "Organic Design"; the subject of modern design was one about which McIlhenny would develop mixed feelings later in his life.

The energies he brought to his Museum job are paralleled in his other major activity, the one that would give him world fame: the formation of his own collection of French pictures. The period between his coming of age and the death of his mother in 1943 was one of remarkable achievement for McIlhenny as a collector. He and his mother were in a very advantageous position: Works of the highest quality were available with relatively limited competition and time could be bought and decisions measured carefully, although some were made with astonishing rapidity. Frances McIlhenny participated actively in many of the purchases and if McIlhenny could write to Mitchell Samuels at French and Company in 1937—"I have shown Mother the Ispahan carpet and naturally she would love to have it. I am so interested in paintings that poor mother has a struggle to buy anything else"—he could refuse with equal vigor a request to loan Delacroix's *Death of Sardanapalus* in 1936, noting that it was one of his mother's favorite pictures and that she simply would not let it out of the house.

And buy they did. The winter of 1935 brought three major drawings: the 1811 Ingres Roman drawing of the artist's friend M Jal, from Knoedler in New York; the small Toulouse-Lautrec

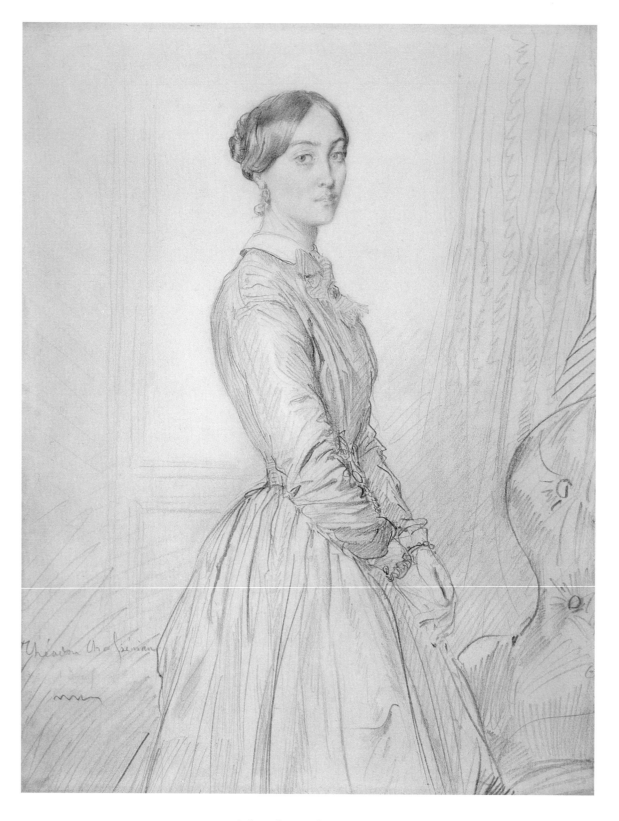

Théodore Chassériau
French, 1819–1856
Mme Burg de Balsan, 1847
Graphite on white paper, 13⁹⁄₁₆ x 10½″

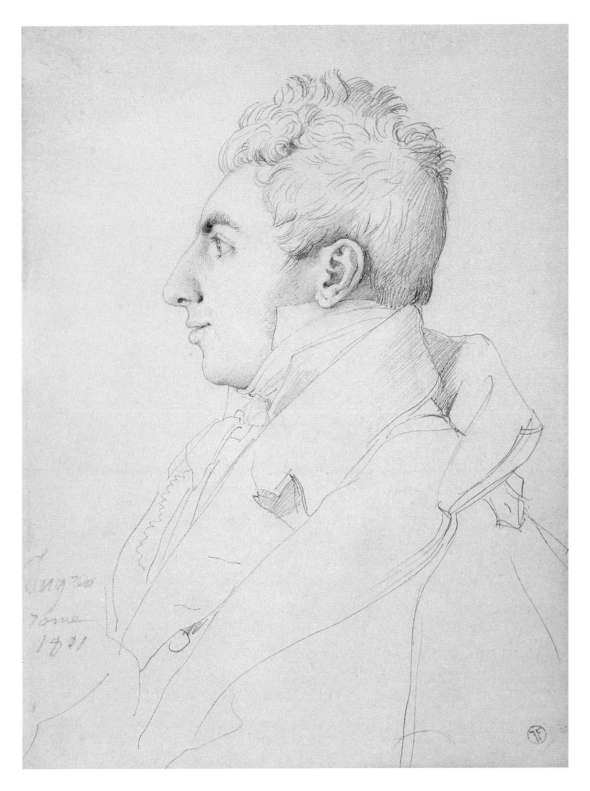

Jean–Auguste–Dominique Ingres
French, 1780–1867
Portrait of M Jal, 1811
Graphite on white-wove paper, 8³⁄₁₆ x 6⁵⁄₁₆″

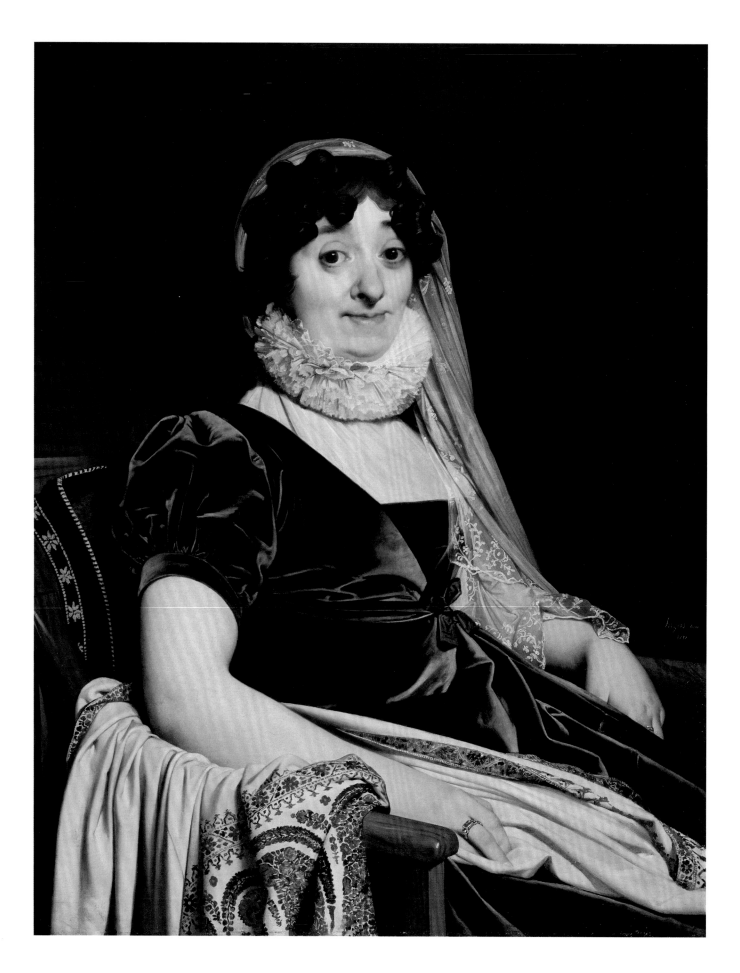

self-portrait, so objective in its self-characterization, from Jean Cailac in Paris; and the Chassériau pencil portrait of Mme Burg de Balsan from Wildenstein in New York. The Ingres drawing served as a preamblc to McIlhenny's most significant purchase that year: Ingres's portrait of the formidable countess of Tournon painted in Rome in 1812. McIlhenny had caught wind that the picture was with Paul Rosenberg in Paris and wrote to Agnes Mongan, who was at the Fogg working on Ingres, in April. She replied, and after remarking on the profound ugliness of the sitter, Mongan applauded it as something to go after. She also mentioned that Sachs would like to have it for the Fogg above all other Ingres portraits. Ingres's 1851 portrait of Mme Moitessier (now in the National Gallery of Art in Washington) was also on the market at the same time; for the three connoisseurs there was no comparison between the two paintings. Rosenberg formally offered it to McIlhenny in June, and the painting was shipped during that month directly to the Fogg, where it was placed on loan. As he liked to observe later, this was the only major picture he ever bought without seeing first. The quality and grand presence of the portrait certainly justified his impulsiveness.

That summer in Paris he saw the set of Degas bronzes with the dealer André Schoeller and was completely taken by the *Little Dancer of Fourteen Years*. This work, the only sculpture shown by Degas in the artist's lifetime (in the plaster and wax model), caused a great sensation for its realistic colorization and actual gauze tutu. It always held a place of honor in any room where McIlhenny displayed it, and he often bragged at his foresight in getting the dealer to sell him an extra skirt.

Jean-Auguste-Dominique Ingres
French, 1780–1867
The Countess of Tournon, 1812
Oil on canvas, 36⅜ x 28¹³⁄₁₆″

The year of the Museum's Degas exhibition, 1936, was also a dynamic one for McIlhenny the collector, and it is difficult to know whether the searching for loans for that show prompted still more acquisitions. As he was for Sachs, Degas was always McIlhenny's favorite artist. He bought that year, besides *Interior*, Degas's pastel *Mary Cassatt at the Louvre* from Jacques Seligmann. This image served Degas in a variety of ways: he depicted the figure in the Etruscan galleries on one occasion and in the painting galleries on another. Cassatt's Philadelphia connection pleased McIlhenny, and he was elated when the Museum, the following year, was able to buy Degas's *Ballet Class*, which she had persuaded her brother Alexander J. Cassatt to purchase and was acquired from his descendants.

If the Degas acquisitions of *Interior* and *Mary Cassatt at the Louvre* came relatively easily to McIlhenny, the other major purchase of 1936 was accomplished through much struggle and even more patience. In April the Paris-based American dealer Martin Birnbaum, who had known McIlhenny from earlier visits, wrote that the marquis de Ganay might be willing to sell Jacques-Louis David's portrait of *Pope Pius VII and Cardinal Caprara*, done from life in preparation for the vast machine in the Louvre, *The Coronation of Napoleon*.[18] McIlhenny was hugely taken by the idea and, even knowing that David's great early equestrian portrait of Count Potocki might leave Poland and also be put on the market, he instructed Birnbaum to proceed although the price would, in all likelihood, be extremely high. McIlhenny saw the picture in Paris that June; his desire to have it became absolute. Sachs supported his pursuit, as did Kenneth Clark when he visited the Degas show that fall. As Clark noted, with a major

Jacques-Louis David
French, 1748–1825
Pope Pius VII and Cardinal Caprara, c. 1805
Oil on panel, 54⅜ x 37¾"

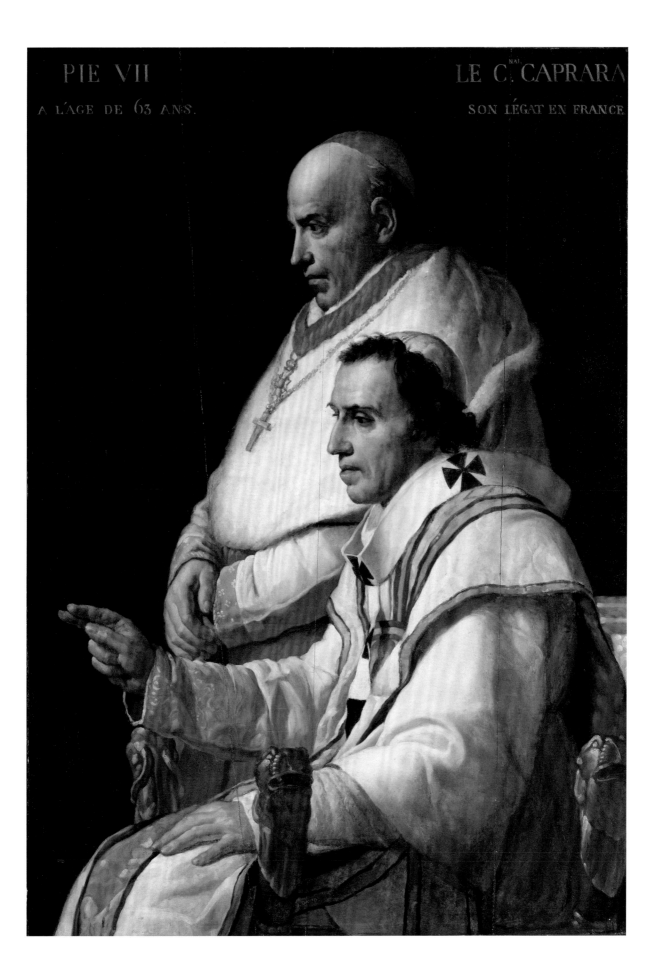

PIE VII
A L'ÂGE DE 63 ANS.

LE C.^{NAL} CAPRARA
SON LÉGAT EN FRANCE.

Ingres already in hand, McIlhenny would, through landing the David, have two masterpieces by the pillars of French art. However, his mother was less keen, particularly given the outlay they had made for Degas's *Interior* earlier that year. To make matters worse, the marquis was vague about the price or even his desire to sell at all. Finally, in despair, McIlhenny pleaded with Kimball to buy the picture for the Museum, even though he knew that, with the purchase of Cézanne's *Mont Sainte-Victoire* that summer, the limited acquisition funds were low. Birnbaum then revealed still more pessimistic news, that the picture, in fact, was the property of the marquise, who seemed even more hesitant about letting the picture go than her husband. Cables crossed and at one point both Birnbaum and McIlhenny almost gave up. But by December, with enough time passing to replenish both Mrs. McIlhenny's accounts and Birnbaum's strength to negotiate the price down, McIlhenny was able to move. A letter went off to Kenneth Clark: "The David is ours!" Clark replied immediately: "It will make a magnificent cornerstone to your collection."

For McIlhenny, this august and stern image of the two men, brought by the emperor's command to witness the self-crowning of the conqueror of Europe, was always his most important picture, as he wrote Birnbaum after the painting finally arrived in Germantown: "It is impossible for me to tell you how very thrilled both Mother and I are with the superb David. It really is the most magnificent picture we own and is so good that it kills everything else." Indeed there would be considerable competition for the picture's place of honor over the next five years, but McIlhenny always regarded it as the greatest masterpiece in his collection (if not necessarily his personal favorite). He reconfirmed this opinion in giving it in part to the Museum in celebration of its centennial in 1977.

In the spring of 1936 he bought Seurat's *Les Poseuses* from Mary Anderson, the niece of the renowned collector John Quinn. This exquisite picture was a reduction by the artist of his final, major work, then as now in the Barnes Collection in Merion, Pennsylvania. The presence of the grander, first rendering of the subject in Philadelphia, which is certainly the most complex and studied work ever

Little Dancer of Fourteen Years, by Edgar Degas
(French, 1834–1917), cast in bronze after a wax
executed in 1880, with tulle and silk. Height 39″

done by Seurat, was McIlhenny's justification for selling his own
extraordinary painting in 1970, when it caused a sensation at auction.
This kind of refined artistic problem, a painter analyzing his earlier
achievements through a reduced replica, always intrigued McIl-
henny. It was in fact one of the things about Delacroix's *Sardanapalus*,

painted some seventeen years after the artist had completed his huge picture, that most interested him. McIlhenny had, just after leaving Harvard, talked about doing some serious study of repetitions and copies—Cézanne after Sebastiano del Piombo, Degas copying Ingres—but other things took precedence.

That summer in Paris he bought a beautifully refined Prud'hon chalk drawing of a nude on blue paper from Eugène Laporte to strengthen further his early nineteenth-century holdings. That same July, he later recalled, he had a particularly happy encounter with a group of artists:

> *Paul Rosenberg, the dealer, took me to lunch at Ermenonville in the Bois with Matisse, Braque and Marie Laurencin. All three were bourgeois and friendly, and we chatted of mundane things, our various ailments, and watched the ducks. How tragically nostalgic such a memory is! Maurice Chevalier arrived and sat at the next table, with a hard blond. The three artists were enchanted, and spent the rest of the luncheon watching the popular star! They never seemed to realize that Chevalier's fame paled beside theirs.*[19]

These three modern artists already figured in the collections of McIlhenny and his sister. The previous year he had bought Georges Braque's Cubist *Wine Glass* and in 1940 would add the poetic oval painting *Violins*.[20] In 1931 his sister had purchased three paintings by Marie Laurencin. McIlhenny owned a drawing and a painting by Matisse, and in 1937 bought *The Blue Dress* for his sister. While sharing a taxi with Matisse, McIlhenny asked the artist to recommend a good figure painting. Noting that *The Blue Dress* was his most important work of that year, Matisse chose this work, which is now in the Museum's collection as a gift of Bernice McIlhenny Wintersteen. Matisse gave McIlhenny the photographs he had taken documenting the long and complex creation of this extraordinary painting.

Renoir's *Grands Boulevards* had been acquired by February 1937 from the Dresden dealer Oscar Schmitz. The work was done the same year as the glorious *Mlle Legrand* and falls centrally within the

Pierre-Paul Prud'hon
French, 1758–1823
Bust of a Female Figure, c. 1814
Charcoal, and black and white chalks on blue paper, 11 x 8¾″

genre of Impressionist landscape, which was not of particular interest to McIlhenny. He was often amused when he was discussed as a celebrated collector of Impressionist pictures, noting that he had works by neither Monet nor Pissarro, the two central figures of the movement, and that most landscapes left him cold. However, this did not prevent him from buying Renoir's radiant cityscape so full of human activity.

Even Cézanne as a landscape painter, despite the young curator's enthusiasm for *Mont Sainte-Victoire*, did not interest McIlhenny for his own collection, and a picture technically owned by his sister of trees at the Jas de Bouffan, the artist's house in Aix, was returned to the dealer after two years. Cézanne's still lifes were another matter, however. Kimball, in writing to McIlhenny in Paris in 1936, noted that the marked copy of the Orangerie Cézanne catalogue sent by McIlhenny indicated *The Black Clock* as sold; he only hoped that the buyer lived in Germantown. McIlhenny had first seen this haunting picture, arguably the greatest early still life by Cézanne, in Paris in 1934 and was determined to have it. But by then he had far exceeded his or his mother's budget and had let the matter rest for the moment. Mrs. McIlhenny did not like the picture, perhaps put off by the dark and brooding quality that sets it apart from the artist's more objective monuments of later periods. But McIlhenny persisted, and by January 1936 he reported to Sachs that his mother had "weakened," only to discover from Felix Wildenstein, to whom the picture had moved, that it was on a three-month reserve with one of the Rothschilds. By the time the picture was free again, Mrs. McIlhenny "put down her foot," noting the limit of funds remaining after the purchase of the Degas and the Seurat. He was deeply disappointed, but in recounting the saga—and he often said that it was the one picture of all those he came near to buying about which he felt most regretful—he would recollect that his mother, in an attempt to console him, noted that he might have grown tired of it in time and, after all, that the clock face was missing its hands.[21]

Not long afterward, McIlhenny had a chance to make up his loss, and as early as Kenneth Clark's visit to the Degas show, he was discussing the comparative merits of *The Black Clock* and *The White*

Pierre-Auguste Renoir
French, 1841–1919
The Grands Boulevards, 1875
Oil on canvas, 20½ x 25″

Sugar Bowl from the J. F. Reber collection, then with Paul Rosenberg. *The White Sugar Bowl* was a picture the Museum had seriously considered when it set out to make a Cézanne acquisition in 1936, ultimately purchasing *Mont Sainte-Victoire*. The still life was sent to Parkgate, but discouraged by the very high asking price, they finally returned it to Rosenberg with regrets. In this case it was the dealer who "weakened" and after McIlhenny and his mother had visited him in Paris that summer, they were able to work out an arrangement with the exchange of Cézanne's *Jas de Bouffan* landscape and a final price somewhat lower than the original. This lyrical and gentle picture—so resolved and untroubled—could not be further from *The Black Clock*, and it is a great credit to McIlhenny, particularly after seeing the show in Paris, that his understanding of Cézanne in his myriad moods was so comprehensive. Like the Seurat, he eventually (in 1983) had to part with it; in the struggle to justify its departure to himself he pointed to the number of Cézanne's already in the Museum's collection, which are now joined by his *Mme Cézanne*.

McIlhenny sometimes wavered in his determination to keep his finances concerted toward nineteenth-century French paintings. Certainly his position as curator of decorative arts encouraged his deep love of objects, and it is unclear what role he played in his mother's

Silver centerpiece, 1697–98, by the French silversmith Elie Pacot (master before 1695, died after 1709). Length 15⁷⁄₁₆″

purchases during the 1930s of eighteenth-century French furniture and of English and Irish silver. He was particularly fond of the two gilded-silver toilet caskets by Thomas Bolton of Dublin that she bought in London in 1936, but it was at lunch in Paris with Mme de Becker during the summer of 1937 that their interest in great silver coalesced. There they admired tremendously the three grand center-pieces by Elie Pacot placed along the center of the table. Such objects—their marks date them to 1697–98—are extremely rare, given the sumptuary laws under Louis XIV and the amount of French silver melted down at the end of the eighteenth century. It was perhaps not too surprising that later in the week at the dealer Léon Helft one of these was offered to them, whereupon Mrs. McIlhenny purchased it immediately. The weighty, architectural basin is now one of the most important pieces of seventeenth-century French silver in an American public collection.

The following years were less hectic in terms of the buying of works of art, just as a more regular pace seems to have taken over McIlhenny's activities at the Museum. Wonderful things, however, continued to come to Parkgate. The beguiling Vuillard painting of a baby and a grandmother was bought from Paul Rosenberg in Paris in 1938; McIlhenny gave it to his mother as a Christmas present. His earlier interest in contemporary art persisted, and he complained in a letter to his mother, who was not with him during the summer of 1938, of arriving in his room in Paris to find that "all six modern pictures" were still placed around the room and not packed up; their identities remain unclear, but they may have been, as in 1933, paintings he was buying for his sister.[22] His particular sense of the importance of Rouault (an opinion he would later qualify) prompted him to buy a small painting, *Veronica's Veil*, from Pierre Matisse, probably in January of 1938; the picture had been painted the previous year. His mother, as McIlhenny would often tell later, reacted promptly, reminding him of his governing principle of buying only the most important things of a kind. The 1918 magisterial *Crucifixion* by Rouault was still available, and she decided they must buy that. Matisse let them keep *Veronica's Veil* as well.

Delacroix's intimate watercolor of his studio fireplace, with pressing irons on the hearth and laundry awaiting on the mantel, was acquired in November 1937 from Jacques Seligmann, New York. In May 1939 he purchased from Julien Levy in New York, Dali's portrait of Harpo Marx at his harp, his mock-mute tongue draped over the top. McIlhenny found this drawing executed in a technique of hard, almost silver-point refinement amusing in its old master reference and completely apt. He commissioned his own portrait in Philadelphia from his friend Franklin Watkins in 1941 and, just as he was about to serve in the war, asked the photographer George Platt Lynes to do portraits of himself, his sister, and his mother. But after the amazing growth of the collection from his Harvard days until 1937, this level of collecting seems mild. The purchase in 1938 by McIlhenny of Glenveagh, an immense estate in Ireland, and the impending war may explain why.

By 1939 the war was already a very real part of McIlhenny's life. Like so many in this country, sentiments were confused and wary, but for McIlhenny, who rarely spoke of this period, the principle was clear. Pictures offered him—a Manet and a Courbet—from Nazi-administered German museums (in these cases Essen and Frankfurt) disturbed him greatly. In July 1940 he wrote his old friend and provider Paul Rosenberg, who had by then made it to Caldas da Rainha, Portugal, expressing his frustration that he could be of so little help. Rosenberg did reach New York safely and his gallery continued to be among McIlhenny's favorite places to look for pictures.

In June 1941 McIlhenny was asked to give the commencement address at the Philadelphia Textile School and School of Industrial Art. It is worth quoting here, since McIlhenny—even with those who knew him well—would often glide away from serious subjects in his attempt to avoid earnestness and make light of his own true feelings:

First, you are lucky to be able to graduate from such schools.
I doubt if similar exercises are possible throughout almost the
entire continent of Europe. Dictatorships do not suffer artistic

Salvador Dali
Spanish, born 1904
Harpo Marx, 1937
Graphite on cardstock, 17^{15}/$_{16}$ x 14″

Georges Rouault
French, 1871–1958
The Crucifixion, 1918
Oil and gouache on paper, 41¼ x 29⅝″

76

freedom. Originality is discouraged; art remains a static servant of the all-powerful state. Countries which sell works of art out of the museums solely because they are Semitic or non-Teutonic present shocking commentaries on what is called Aryan culture. In such an environment art must conform to a standard autocratically established. Here, fortunately, we still have tolerance, and its protection and nourishment are absolutely essential if art is to survive. Our artistic freedom must be zealously guarded, and our minds, our eyes, and our ears must be kept open, and our approach to all forms of art, whether to our taste or not, must be disinterested and unprejudiced. It has been said that the heresies of one generation are the orthodoxies of the next, and this fact alone necessitates the encouragement of new ideas and liberty of expression. A genius is generally one generation in advance of his less-gifted contemporaries, so it takes the contemporaries some years to catch up. Paradoxically, intolerance, too, must be maintained, but should be directed only against the insincere, the second-rate, and compromise with integrity.

Second, America is now practically cut off from Europe, which since our inception as a country has been the source of our artistic inspiration. An American art is gradually evolving, and now that it is relatively independent of foreign influences it has an unparalleled opportunity to grow, to experiment, and to lead. Standing on our own, however, we run great risks—egoism and nationalism. Merely because a thing is American, no cachet of quality, importance, or distinction can be claimed. Unless a work of art is good, based on universal principles, why waste time and energy? We should not lose the chance to create an American art that is truly great and that can be judged good by any standards.

Kimball was braced for the loss of the younger members of his staff. McIlhenny's first thought was that he could be of use in the numerous diplomatic and intelligence operation bases in neutral Ireland. Despite several strong efforts, nothing came of it. Therefore, Kimball, like others, helped him in 1942 to get a commission in the navy as a lieutenant, by writing to the Secretary of the Navy:

Henri de Toulouse-Lautrec
French, 1864–1901
Self-Portrait, 1896
Crayon on off-white wove paper, 10⁷⁄₁₆ x 8⅛″

"Although young, he is on half a dozen of the major boards in Philadelphia, and his enterprise is reflected in his rapid advancement to positions of power and influence. He is very intelligent, facile in absorbing anything new, with a great gift for attracting the loyalty of others. He should have the makings of a very useful officer."

He received his commission in March 1942 and was granted temporary leave from his post as curator of decorative arts at the Museum. Just as he was leaving he wrote Kimball: "I really love the Museum, and I am looking forward to being back on the job as soon as the war is over." He was stationed first in Rhode Island and then Norfolk, where he took a cottage and brought down Rouault's *Veronica's Veil*, Dali's *Angelus*, and Picasso's *Bullfight*; but by the following summer, he was mobilized to the aircraft carrier U.S.S. *Bunker Hill* assigned to the South Pacific. Of the years 1943 to 1945, McIlhenny rarely said anything, other than to note blithely that he was "involved in only the best engagements" in the South Pacific. And he was: the Bismarck Archipelago, Bougainville, the Gilbert Islands, the Marshall Islands, and West New Guinea. His war record was distinguished, and he was indeed in the heart of major conflicts during much of his time on the *Bunker Hill*. The carnage and waste of human lives deeply repelled him, but he acted with complete responsibility and conviction.

At the same time he was frustrated to be detached from the arts, although he did share quarters for a time with the photographer W. Eugene Smith, and his letters are peppered with happy encounters with old colleagues and friends. His mother closed the house in Germantown shortly after he went to the South Pacific and died in town in March 1943. McIlhenny hated to think of moving things out of the house, and he wrote to his sister: "If I should get home, I want everything there, so the house will look as well as possible." He was also concerned about the Museum's exhibition of his father's collections, especially their installation, which he pleaded to have photographed. Other letters show him living vicariously through his sister as her own involvement in the art world became more ambitious. "Mail today and your exciting account of the trip to New

Eugène Delacroix
French, 1798–1863
The Fireplace, 1824
Watercolor with graphite underdrawings and traces of
crayon on off-white laid paper, 7¼ x 9¾″

York with Sturgis [Ingersoll]. I'm crazy to see your Rouault, and agree with you about Miró [she loved him]."

Exhibition catalogues arrived months after the closings of shows. He wrote to his sister in 1943: "The catalogue of the Wildenstein show was sent to me, and must have been grand. At Durand-Ruel is a little Berthe Morisot of a girl before a mirror that Mother almost bought in Paris and often regretted—number 14 in the 100th anniversary show. It's very feminine, and as I remember, very charming. Did you see it? Seeing the reproduction made me feel very nostalgic. We saw it in Paris one autumn, '34 or '35."

McIlhenny was watchful of the Museum, and his letters to his sister from 1943–44 are full of advice: "I was sent a newspaper clipping about the Morgan pictures being on sale at Knoedler. Have you gone to see them? Who will have the power over the Wilstach fund now that Joe Widener is dead? An enlightened person could do wonders, but the person should also be somewhat conservative. Sturgis, for example, is too enthusiastic, and really far-sighted planning is needed."

Dried fruit arrived from home; Gertrude Stein mailed him a book. But the urge was to keep up with his world at home and collecting. "When Watkins wrote me he described one of his recent paintings, subject an angel turning a page in a book. What he said rather fascinated me, so I was delighted to see a reproduction in the May *Art News*. The picture looks interesting, and gave me the acquisitive urge, so I wrote Rehn asking the price and so forth. Doubtless, it's already sold. . . . It's foolish, of course, to buy sight unseen, but at this point, I've got to do something or burst."

McIlhenny was advanced to lieutenant commander, yet except for actual encounters about which censorship disallowed any mention ("As you must know from the papers, we're busy again"), his days were filled with the tedious routines of duty officer and writing much of the captain's correspondence. By 1944 his urge to be more involved with something where his talents would have purpose was almost insurmountable; the newly organized special group to deal with liberated museums and monuments in Europe was constantly on his mind. He wrote to his sister in January 1944:

Marvin Ross [of the Walter's Art Gallery] got his order yesterday to fly back to Washington and thence to Italy to look after works of art!!! It really is so very sensible that it's unbelievable. Of course he's delighted, because it's a job he's admirably trained for. Now if only Francis Taylor [of the Metropolitan Museum of Art] and Sachs would summon me! Marvin promised to do what he can, but I'm not optimistic. France would be the best for me, because of the 19th century paintings, but almost any European museum would be satisfactory!

Nothing came of it and he continued on the *Bunker Hill* until late October of that year when he came home on leave. "The Art World promises to be quite active this winter, according to all reports," he wrote his sister just before taking leave, "an excursion to New York is one of the things I'm looking forward to most."

In January 1945 he was stationed in Washington at the Bureau of Aeronautics, where he took a house in Georgetown. He was discharged a year later and immediately rejoined the staff of the Museum.

Edouard Vuillard
French, 1868–1940
The Meal, c. 1899
Oil on cardboard, 18½ x 18¾"

GLENVEAGH
1934–1983

❧

GLENVEAGH CASTLE SITS IN A DESOLATE AND ROMANTIC place, in County Donegal in the far north of the Republic of Ireland. Built in 1870–73 by John Adair, whose fame survives even today for his ruthless clearing of the land to create a deer forest and pleasure grounds containing 32,000 acres. It was purchased in 1929 by Arthur Kingsley Porter, a Harvard scholar of French medieval art and architecture. McIlhenny met Porter when he was a student at Harvard during the 1930s, and after Porter disappeared from Glenveagh mysteriously in 1933—having gone out for a walk on Inishbofin, an island just off the coast—Mrs. McIlhenny rented the house the following summer.

Both mother and son fell in love with the place, and McIlhenny bought it outright in 1937. McIlhenny's grandfather had emigrated from Milford, County Donegal, in 1843, and whereas McIlhenny was never chauvinistic about Ireland, he was tremendously comfortable there, often commenting that it was only a question of "back to the bogs in three generations." Glenveagh castle was grand and accommodating, and while "erected in the worst Victorian decade," it was a place that would give him and many guests great pleasure during the next forty-six years. Around it he created gardens that for their subtlety and variety rank as some of the finest creations of their kind in this century.[23] For the house itself, which Mrs. Porter had furnished in a rather conventional 1920s fashion, he set out to find a style that was appropriate and that would provide a new impetus for the pursuit of beautiful things.

For McIlhenny certain themes were clear: eighteenth-century Irish furniture and silver whenever possible. As early as 1938 McIlhenny had enlisted the remarkable Father Daniel J. Lucey of

Dublin in his search. Mantels and sideboards were filled with silver and ceramic garnitures, and large table services were provided, along with major pieces of Irish silver, such as a pair of large two-handled cups by Mathew West bought in 1951. In 1946 a Sheffield regimental branched candelabrum measuring thirty-one inches high was bought for the main sitting room. The enchantingly playful Rococo epergne by Emick Römer (marked 1768), while English, was found by Father Lucey in Dublin in 1952; its suspended dishes were always filled with marzipan fruit for parties at Glenveagh. A two-handled covered cup by Robert Calderwood came in 1953. If the pieces by eighteenth-century Irish silversmiths, who adapted English forms and added, often slightly incongruously, their own inventions, seem somewhat naive and provincial, they amused McIlhenny immensely. He complemented them with such sophisticated forms as two Neoclassical chestnut urns by Daniel Egan, which he bought in Dublin in 1967.

Mahogany side table with marble top, c. 1740, possibly Irish. Height 32″

Silver epergne, 1768, by the Norwegian silversmith Emick Römer (active London, c. 1765–75). Height 13½″

For paintings his first notion was to stay within the eighteenth century as well, at least for the principal rooms; but as time went on, the house began a jolly mix of styles, with one bedroom containing only engravings after Canova bought in Rome, another literally papered with Neapolitan watercolors of Vesuvius erupting, and a hallway filled with a suite of prints of the birds of Mount Desert by McIlhenny's friend the painter and collector Carroll S. Tyson, Jr. One of his earliest important purchases, quite out of vogue when it was bought in 1938, was George Stubbs's *Deer Hunt*, which shows Freeman, the earl of Clarendon's huntsman, about to garrote a doe. This picture, so appropriate to a stag-shooting place, hung in the main drawing room until it was sold to benefit the Museum in 1977. An amusing eighteenth-century English still life featuring a tortoise, whose history is carefully recited on the painting itself, hung in a room that was full of silver-mounted tortoise boxes.

Black
English, 18th century
Still Life with Tortoise, 1743
Oil on canvas, 29½ x 38″

But in the late 1940s the focus changed and McIlhenny began to collect the Victorian pictures that would form the core of his second painting collection. Unlike the French paintings, these were never formulated as a group with the same hard pursuit; they were bought to be enjoyed in a house where he spent the summer, and he was often perplexed later (although certainly pleased as well) to see how seriously such things were being taken. The relaxed tone had been set early on, as is revealed in a letter from Glenveagh to his Museum office, written in September 1937:

> *Ireland has been a great success in every way, although the country is shocked by the lack of a chaperone. Nine stag have been shot, one being the crude handiwork of your associate curator of decorative art. The fishing has been excellent, and to my infinite surprise, I killed (caught to you) a salmon! In comparison, Daumier is just too dull. Donegal is not art conscious, thank god, and after a month on the continent, I couldn't have looked at another object. I really am reverting to nature.*

The pleasure in densely painted romantic pictures of nineteenth-century England was not, in many ways, foreign to the generation of McIlhenny's parents. Perhaps not too surprisingly, one of the first nineteenth-century paintings he bought for Glenveagh was by the American Arthur F. Tait: *Home of the Deer, Raquette Lake, Adirondacks,* 1880. McIlhenny's parents had collected Currier and Ives prints done after Tait's pictures in their summer house at Prout's Neck. But it was only in the late 1940s that he began buying the works that would transform the house and make it, as one critic half-seriously noted, an "American challenge to Balmoral."[24] In 1949 he bought from Mr. and Mrs. Robert Frank in St. James's, London (the dealers who would be to his Victorian purchases what Rosenberg was to the French pictures), a Richard Ansdell conversation piece, which he would discover only later showed John Naylor and his wife on their honeymoon trip to Corndavon Lodge, Aberdeenshire. Naylor, an exceedingly successful Liverpool banker, was a keen sponsor of young English artists and even after Ansdell's move to London from

his native Liverpool, Naylor continued to give him his full support. This picture was painted in London in 1847, and McIlhenny related the family's story of the dead stag, which was brought down from The Highlands as a studio prop and must have been unbearable after the long journey. Naylor's collection, which contained ten paintings by Turner, had also included some of the major works of Queen Victoria's favorite painter, Sir Edwin Landseer, for whom McIlhenny developed a passion. He had bought fifteen by the time he left Glenveagh permanently in 1983.

The first Landseer was a sketch of the duchess of Bedford's hut at Glenfeshie, bought from the Leicester Galleries, London, in 1950; the picture cost forty-two pounds. By March of the next year, his sights had lifted, and he was considering an offer from Lord Moyne to sell Landseer's most famous picture, *The Stag at Bay*, then on loan to the Iveagh Bequest, Kenwood. McIlhenny thought the asking price was too high, but at the same time he opened negotiations for the purchase of the other great Landseer from the Guiness family, *The Braemar Gathering*, although the picture's scale, nine by eight feet, made it too large even for Glenveagh. *The Bride of Lammermoor*, from about 1830, done as an illustration for Sir Walter Scott's *Waverly Novels*, came from Thomas Agnews & Sons, the London dealer, in 1953. *A Trout* was rejected in 1954 from the dealer Leggatt, but in

Oak bench, c. 1828, attributed to the architect Augustus-Charles Pugin (French, active London, 1762–1832), probably made by Morel and Seddon, London (established 1827). Length 59″

Richard Ansdell
English, 1815–1885
Mr. and Mrs. John Naylor
with a Keeper and Dead Stag, 1847
Oil on canvas, 41 x 72"

Silver chestnut urn, 1815, by the Irish silversmith
Daniel Egan (mark entered 1800). Height 13¼″

1956 he acquired, again from Agnews, two large canvases: *Two Stags
Battling by Moonlight* and its aftermath the next morning depicted by
two dead stags and a fox. For one lucky enough to have sat facing
these paintings in the Glenveagh dining room in early October while
outside the beasts roared their calls across the lake, the sense of union
between art and nature was unforgettable; such was the effectiveness
of this Tennysonian theater—the terrible splendor of nature being
played out quite apart from man as witness. The poignant *Ptarmigan*
came from Mrs. Frank at this time, followed by the *Falconer*, an
unfinished portrait of Lord William Russell, son of Georgiana, the
duchess of Bedford.

As apt as Landseer and Ansdell were for Glenveagh, they were
not the only Victorian painters McIlhenny wanted; the whole subject

Sir Edwin Landseer
English, 1803–1873
Ptarmigan, by 1833
Oil on panel, 19¾ x 26″

OVERLEAF
Sir Edwin Landseer
English, 1803–1873
Two Dead Stags and a Fox (Morning), before 1853
Oil on canvas, 56 x 103″

interested him greatly and he often regretted that the Museum had missed out on important Pre-Raphaelite works such as those at the Fogg, given by Grenville L. Winthrop.[25] The closest he came was two charming genre pictures, *For Sale* and *To Let*, by James Collinson, who was briefly a member of the Pre-Raphaelite Brotherhood but had rejoined the more conventional mainstream of Victorian painting by the time he did this pair of works in the late 1850s. Bought in 1951, they shared the upstairs sitting room with John Calcott Horsley's *Lovers under Blossom Tree*. Purchased from Robert Frank in 1950, it had been shown at the Royal Academy to great acclaim in 1859. *The Surprise*, the little picture by Arthur Boyd Houghton, cost slightly more than the Landseer of Glenfeshie and was bought the same day in 1950 at Leicester Galleries for fifty-two

English lady's work table, c. 1860, painted and gilded papier-mâché, inlaid with mother-of-pearl. Height 30½″

James Collinson
English, c. 1825–1881
For Sale, late 1850s
Oil on canvas, 23 x 18″

James Collinson
English, c. 1825–1881
To Let, late 1850s
Oil on canvas, 23 x 18″

Arthur Boyd Houghton
English, 1836–1875
The Surprise, c. 1860
Oil on canvas, 9¼ x 7½″

John Calcott Horsley
English, 1817–1903
Lovers under Blossom Tree, by 1859
Oil on canvas, 35½ x 27¼"

pounds; this diminutive hot house of Victorian emotion was perfectly in keeping with the pictures he liked to have for himself and his guests at Glenveagh. He enjoyed pointing out to the unobservant that the boy was biting the girl's ear. In 1950 McIlhenny tried for at auction, but lost, William Powell Frith's reduced version of one of his most ambitious pictures, *The Railway Station*, of which the large version is at Royal Holloway College in Egham, England.

Purchases continued for Glenveagh throughout the 1960s and 1970s—carved cameos, Regency furniture, a fine French Empire sideboard. One room was decorated with five pieces of furniture made of black papier-mâché and inlaid with mother-of-pearl, one of them bought in Philadelphia. Nineteenth-century Roman busts were found for the gardens and two life-size figures of Flora and Bacchus from Fratelli Romano in Florence were added to decorate a newly created Italian garden at the top of the hill. In 1973 an Egyptian obelisk was hauled up the hill to anchor the vista from the pleasure garden.

In the early 1960s Lord Rossmore gave McIlhenny the serenely sensuous marble sculpture of Venus and Cupid by Benjamin Edward Spence for his new Gothic winter garden designed by Philippe Jullian, the French bibliophile and scholar of Surrealism. His sister bought for him from the Grittleton sale in London in 1966 a Richard James Wyatt marble statue of Ino and Bacchus, which he placed against a rusticated wall cascading with ivy. Both sculptors had worked in Rome in the first half of the nineteenth century with those Americans whom Henry James tagged the marmoreal flock and were much favored by John Naylor of the Ansdell portrait; in fact, Naylor had in his house Leighton Hall eight works by Spence.

Venus and Cupid by the English sculptor Benjamin
Edward Spence (1822–1866) shown in the Gothic
winter garden at Glenveagh. Marble, height 63"

The withdrawal from Glenveagh when it was deeded over to the Irish Parks and Monuments Service in 1983 was emotionally difficult for McIlhenny. Only the major works of art returned to Philadelphia, since the house would now be open to the public. In preparation for his departure McIlhenny sought out Landseer prints to replace many of the paintings. The last work of art he received there gave him particular pleasure. In 1982 Joseph and Emily Pulitzer brought Ellsworth Kelly to visit, and Kelly drew, as a house gift, one of the leafy branches of a datura tree in the garden.[26] In 1979 the Museum had acquired Kelly's severe and eloquent *Diagonal with Curve III*, none to McIlhenny's delight, but he did admire this work and often commented on the accuracy and grace of the depiction; it reminded him of his Matisse drawing, *The White Plumes*.

Silver candelabrum, 1778, by John Scofield of London (mark entered 1778). Height 18½″

Ellsworth Kelly
American, born 1923
Datura Leaves, 1982
Graphite on off-white wove paper, 22 x 30″

GERMANTOWN
1946–1951

A S MANY OF THE FRIENDS WHO KNEW HIM WELL HAVE
noted, Henry McIlhenny had changed by the time he returned
from active service in the war. Much of his youthful zest and
headstrong enthusiasm had subsided, and the return to civilian life
was not without a certain flatness. He wrote a friend from George-
town in 1945 where he was waiting to be mustered out of the navy,
mentioning his mixed feelings about returning to Philadelphia. With
the death of his mother in 1943, life in Germantown at Parkgate
would be very different; the house was denuded, and in 1946 he and
his sister were to sell off, in a three-day sale at Parke-Bernet in New
York, many of their parents' possessions to settle the estate.

The Museum itself had changed. Much of the push to complete
galleries was over and a larger staff covered many of the areas
McIlhenny had taken charge of before the war. McIlhenny's friend
Louis Madeira joined the Museum in 1948 as assistant in the depart-
ment of decorative arts and took over most of the daily tasks. Henry
Clifford, as curator of paintings, was tremendously active, and it is
perhaps not surprising that McIlhenny played no role in organizing
the Museum's Matisse exhibition in 1948, other than, of course, as
an important lender.

This is not to say that it was a passive time in McIlhenny's life;
it was a period of sorting things out and of adjusting to a more limited
income, for he was now without the participation of his mother in
his purchases. Glenveagh became a consuming passion and Parkgate
itself, with the great carpets and Renaissance furniture now at the
Museum, was transformed more completely to his own taste. Many
of his purchases were contemporary works of art: Pavel Tchelitchew
drawings; paintings by Walter Stuempfig, from Durlacher Bros. in

New York; Charles Demuth watercolors bought in Lancaster, the artist's home; and three important oils by Marsden Hartley.

His boldest move was to commission from his friend Franklin Watkins two huge paintings for the gallery where his parents had shown carpets and tapestries: "Dear Watty: The big room at my house is completely empty both of paintings and furniture, and I am wondering if you would by any chance be interested in painting several really large pictures which would act as murals. I know of no other American artist that I would want to execute such a commission." Watkins proposed the themes of Death and Resurrection for two canvases measuring nine by almost fifteen feet. Their progress was reported with photographs to Sachs and Agnes Mongan at the Fogg. The murals were unveiled in Germantown on January 30, 1949. When they were shown together with the preparatory oil and watercolor sketches at the Museum of Modern Art in New York the following year in an exhibition organized by Andrew Ritchie,[27] reviews were mixed, and the critic Henry McBride in *Art News* was particularly harsh about the pretension of the subject matter. McIlhenny immediately fired off a telegram to Alfred Frankfurter, the publisher: "Shocked by cheap superficiality of McBride's article, which is merely humorous and destructive, not constructive criticism."

Fiske Kimball continued to encourage McIlhenny to organize exhibitions, but no major show was undertaken by him in the late 1940s. Plans were advanced in 1947 to do an ambitious exhibition of the French Empire style, something that McIlhenny in his own collection was already beginning to explore as early as 1935 and that he would build on with greater strength in the 1950s. This project was set aside, however, because of the leave of absence McIlhenny took in 1947–48 to be resident art historian at the American Academy in Rome. Bernard Berenson, whom he had known through his parents, encouraged him to put together a complete list of Renaissance sculpture, along the lines of his own publications on Italian paintings. As he honestly reported to Kimball from his "charming villino on the very top of the Janiculum" in February 1948, "I am ashamed to

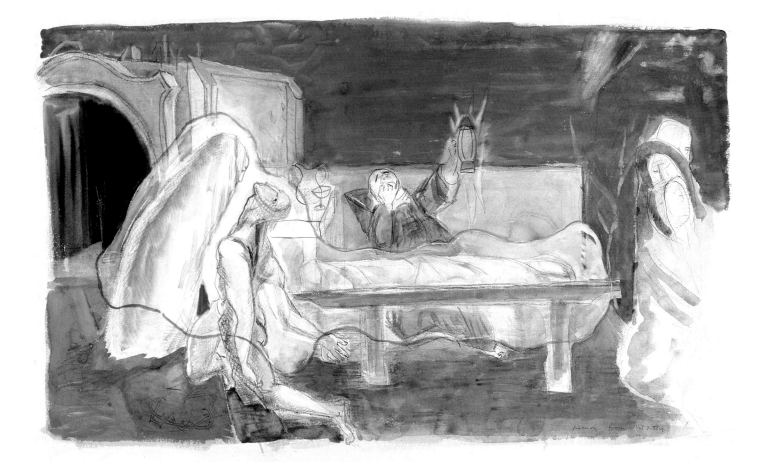

Franklin C. Watkins
American, 1894–1972
Study for *Death*, 1947
Opaque and transparent watercolor, and ink and graphite
on cream wove paper, 23⅜ x 37³⁄₁₆″

Pavel Tchelitchew
Russian, 1898–1957
The Eye (Study for *Flowers of Sight*), 1944
Ink and watercolor, with traces of charcoal
on cream wove paper, 11⅜ x 14⅞″

confess that I haven't accomplished nearly as much as I'd expected," and nothing was ever published.

His stay in Rome confirmed for him a love of Italy, a place he had not known well before the war, and in his frequent correspondence with Kimball it was major Italian pictures he pressed for the Museum. Both McIlhenny and Kimball were saddened that the Museum could not acquire from the earl of Harewood, Titian's *Diana and Actaeon* (now in the National Gallery, London), which McIlhenny first saw when he was searching for Robert Adam commodes for the Museum's newly opened drawing room from Lansdowne House, London. He was equally frustrated when Kimball responded to his report from Rome that an important Bernini sculpture might be on the market: "I would rather stick to paintings." In 1951 he returned to Italy to see the Caravaggio exhibition in Milan and argued hard for the Museum to buy *Saint John the Baptist*, which was available through the young dealer David Carritt, who would become a close friend of McIlhenny's. Neither Kimball nor Henri Marceau weakened, and the picture is now at the Nelson-Atkins Museum of Art in Kansas City—perhaps its most important painting. He also wrote with excitement that the prince of Lichtenstein was forced to sell his print collection: "There are 80,000 prints, 10,000 of which are said to be top-notch. The remainder constitutes a superb print cabinet, the like of which does not exist in America, I'm told. . . . The drawings from the same source are being or are to be sold in Zurich by this agent and there are five Dürers, and so forth." This time Kimball did attempt to act, sizing up the American competition carefully and reporting his progress to McIlhenny; in the end, however, the collection was withdrawn from the market as a unit. McIlhenny was able to buy, with funds given by his sister, one important Italian picture for the Museum, Bronzino's *Cosimo I de' Medici as Orpheus*, which was brought to his attention by Carritt in 1950. "Certainly the price is not too high." It was 4,400 dollars.

This was a relatively slow moment for McIlhenny in the building of his own collection at Germantown, other than modern acquisitions. He wrote Sachs in December 1946: "My collecting activities recently have been practically nil. I remember during the museum

course you once said that collectors usually are not active more than one generation because it is hard to reconcile the prices of one's youth with the prices of one's maturity. The war has telescoped a generation, and the prices in New York really shocked me." He did buy a "curious seventeenth-century French still life" in London in 1950, which is actually by the Dutch artist N. L. Peschier, one of only seven known works by this painter. When he was later asked why he was drawn to this rather atypical picture in the context of his own collection, he liked to note glibly that he admired the money bags. Two girandoles came from the London antiques show that same year as well as a Jean-Baptiste Carpeaux plaster for the figure of *Dance* from the facade of the Paris Opéra. But the really great addition—the last monumental painting that he was ever able to buy—was Vincent van Gogh's *Rain*, which he bought at the gallery of Paul Rosenberg in New York in April 1949.

Recumbent Stag by Elie Nadelman (American, born Poland, 1885–1946), c. 1915. Bronze, length 20¼″

N. L. Peschier
Dutch, 17th century
Vanitas, 1661
Oil on canvas, 31½ x 40″

McIlhenny had already been thinking about van Gogh during the war, in November 1943, when his sister was reporting on the New York art world and her own interest in the artist's works on the market. He wrote her from the *Bunker Hill*:

> *The New Yorker review of the van Gogh show is good. Did you see anything top notch? "The Gardens at Arles," a superior version of the Duncan Phillips painting, is brilliant and would suit me perfectly. Before buying a van Gogh, it should be very carefully inspected under ultra violet, etc., because large pieces of pigment have come off, and I know that some of his pictures have large repainted passages. Rosenberg once showed me several in "unshowable" condition.*

Earlier that month he had written her: "Only a limited number of van Goghs seem to me to be really great. They lack thought and logic and often are just emotional fire works. Thus they lack depth and grow tiresome. For example, the Lewisohn *L'Arlésienne* [Metropolitan Museum of Art] bores me. However, he did do really great things, and I would love one someday."

And McIlhenny found the one—the view from van Gogh's asylum window in the hospital at St. Rémy out across a rainswept plowed field: "What more poetic metaphor for angst?"[28] It was a difficult decision, and not an easy purchase, for McIlhenny, one that required considerable sacrifice. Trust officers needed to be persuaded and payment arranged over two years. To restore his finances partially, he sold two other pictures, his large 1931 Picasso *Still Life with Pitcher and Bowl* to Nelson Rockefeller, bought in 1942, and the lovely oval Cubist painting by Braque. Even if he was less solvent than before, his spirits were resilient. Complaining to David Carritt, who was offering him Turners in December 1950, he wrote: "I personally am not in a buying frame of mind. . . . However, as you know, I have no control when it comes to works of art, so send all the photographs." Not the least of his financial burdens, beyond the outlay for *Rain*, was the expense of renovating a house he had bought in the center of Philadelphia at 1914 Rittenhouse Square.

Vincent van Gogh
Dutch, 1853–1890
Rain, 1889
Oil on canvas, 28⅞ x 36⅜″

RITTENHOUSE SQUARE
1951–1986

W HEN THE COLLECTOR AND PATRON LISA NORRIS ELKINS died in the summer of 1950, she left her Rittenhouse Square townhouse as well as her pictures to the Museum.[29] McIlhenny heard that the house was for sale and wrote to Fiske Kimball from Ireland in August: "Lisa Elkins' death was an awful shock, and I'll miss her a lot. . . . Her house . . . would seem . . . perfect for me, although the Martin-Rosenbach house on Delancey[30] is larger and better, but, alas, not on the market at the moment. It would be a job to fit in all my possessions, but I'd simply have to eliminate some."

McIlhenny bought the house from the Museum and solved the space problem by buying the house just west of No. 1914 Rittenhouse Square, tearing it down and having his friend the architect George Roberts design a formal entrance and a garden behind. Roberts built as well a pedimental niche in the garden to hold McIlhenny's charming *Venus and Dolphins* fountain, which he bought simply as school of Antonio Canova but which has more recently been attributed to the Swiss Neoclassical sculptor Heinrich Keller. Like his transformation of Parkgate and the castle at Glenveagh, the making of the Rittenhouse Square house was the kind of adventure McIlhenny enjoyed the most—"a new installation," he joked with fellow curators.

He launched into the project with great vigor: "My house is going to be absolutely marvelous, and my pictures look extremely well in their new setting," he wrote to David Carritt in 1951. He even broke his usual summer at Glenveagh in 1951 to start the move in July, having stopped on his way back from Rome to buy a set of *bois clair*, or light wood, armchairs, stamped with the name of the French furniture maker Werner, from Jean Chèlo on the rue Lamen-

nais in Paris, as well as a gueridon with claw feet. This type of furniture, which domesticates Empire designs and plays off broad areas of variegated wood surfaces with elegant flat gilded-bronze mounts, is sometimes referred to as the style of Charles X, after the king of France from 1824 to 1830, although it is better placed in the broader category of *bois clair*, or Restoration (1815–30). Over the next ten years, it would fill the two formal drawing rooms on the first floor, where many of the major French pictures were hung, and create, as an ensemble, the most important gathering of this furniture in the country. It was not a new taste for McIlhenny. In 1935 he and his mother had bought a suite of light-wood furniture—including a cabinet, four side chairs, and two matching armchairs—in this style from Arnold Seligmann, Rey & Co. in New York, only a month after he had purchased the Ingres portrait of the countess of Tournon that reigned so comfortably over it in two quite different settings. Paul Sachs would write in February 1937, having just visited Parkgate, that he thought Renoir's portrait of Mlle Legrand was perfectly suited for the "Empire Room."

McIlhenny would add to this group of objects throughout the 1950s, and there is a 1957 sketch in his own hand showing how he wanted to arrange the things he had seen that October at Chèlo, including lamps, two tables, two canapés, and two taborets. As illustrated in *l'Oeil* in 1957, the furniture was covered in velvet and striped satin. However, a fire screen he had found still retained its original fabric of deep scarlet with a pattern of gold vases with blossoms and disks and he eventually had it reproduced for all the furniture in the two rooms. At the dealer H. Blairman in London in 1958 he found an opulent porphyry-topped center table supported by two bronze caryatids whose origin continues to perplex specialists of nineteenth-century furniture. Although this object does not fit historically into the carefully thought out context, for anyone who knew the house, it anchored the long drawing room beautifully. By the 1960s his taste would turn more toward the grander Empire forms of the earlier part of the nineteenth century. He would then write a fellow collector of *bois clair*, Mme Renée Gesmar in New York, that he had finished his room and did not need any more.

While McIlhenny's furniture collection is known mostly for its Restoration pieces, other objects were sought for the house, nearly all of them by the best known French makers of the eighteenth century, and while his paintings, with the exception of the Chardin, had no immediate point of reference in this context, it was a happy fit. He had inherited from his mother such fine French furniture as an oval writing table with a complex marquetry top, attributed to the German maker (working primarily for the French market) David Roentgen, and two charming *voyeuses*, or chairs for watching card games, signed Jacob. Mrs. McIlhenny's taste was very much to the upright elegance of Louis XVI and many of her pieces were given a place of honor at Parkgate in her son's "installation" of that house after the war. However, at Rittenhouse Square most found their way to greater obscurity in bedrooms upstairs as McIlhenny proceeded to search for more splendidly worked pieces. The grand commode

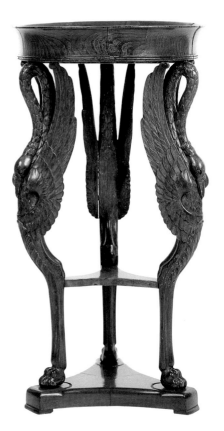

French fire screen of burled birch with mahogany inlay, with original woven-silk fabric, c. 1825–30. Height 38″. McIlhenny's French Restoration furniture was upholstered in fabric woven to reproduce this pattern.

French table of burled elm with elm veneer and painted wood, c. 1825–30. Height 29″

Armchair, c. 1825–30, by Jean-Jacques Werner (French, born Switzerland, 1791–1849), of burled-ash veneer with mahogany inlay. Height 37⅛″

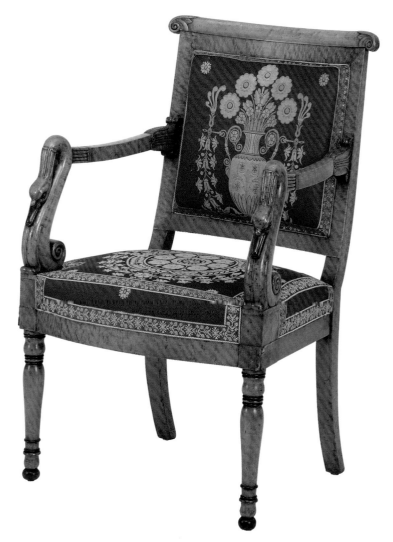

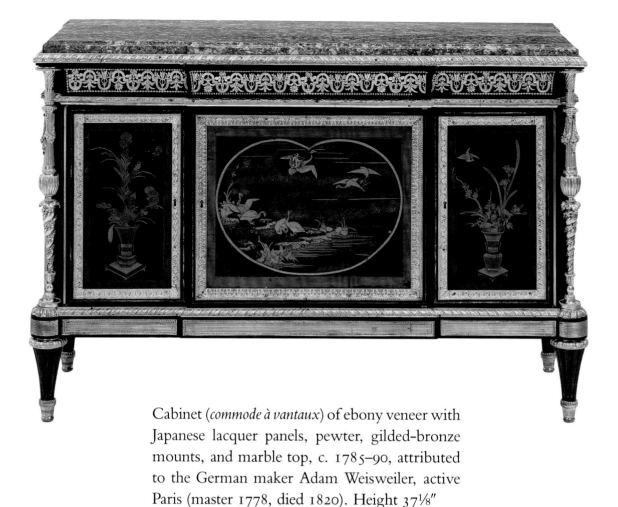

Cabinet (*commode à vantaux*) of ebony veneer with Japanese lacquer panels, pewter, gilded-bronze mounts, and marble top, c. 1785–90, attributed to the German maker Adam Weisweiler, active Paris (master 1778, died 1820). Height 37⅛″

attributed to Adam Weisweiler, with brilliant gilded mounts, pewter inlay, and Japanese lacquer panels, was the level of importance that he sought. While unsigned, the piece is similar to one given to the Metropolitan Museum of Art by McIlhenny's friends Jayne and Charles Wrightsman. Scholars speculate that it may date to after 1789, when Weisweiler, having lost his French aristocratic patrons, continued to produce objects of the greatest luxury for German and Russian clients. In this same category, although less clearly attributed, is the pair of matching boulle cabinets that McIlhenny bought from Rosenberg and Stiebel in New York in 1952 and whose provenance includes Baron Nathaniel de Rothschild in Vienna and the Hamilton Palace sale of some of the greatest pieces of eighteenth-century French furniture. They were sold to him as Louis XIV but as McIlhenny noted in a letter to Henri Marceau when he was in Europe searching for furniture for the Museum's new Louis XIV period room, "The

difference between Louis XIV and Louis XVI Boulle isn't as marked as one might think." McIlhenny always thought that his own objects might well fall into the second category and others have now suggested the same (with certainly a still later reworking of the top section above the scroll capitals), but this does not, nor did it for him, diminish the pleasure to be found in them.

A beautifully carved and gilded six-fold screen for the dining room came from the same New York dealers, signed on two leafs with the mark of Jean-Baptiste Tilliard. Two white and gilded cross-legged stools arrived shortly thereafter and are attributed to Séne, Vallois, and Chatard; they are from a set of sixty-four commissioned from Séne for the chateaus of Compiègne and Fontainebleau by Marie-Antoinette.

Commode of ebony veneer, tortoise shell, and brass, with gilded-bronze mounts and marble top, c. 1715, after André-Charles Boulle (French, 1642–1732). Height 36½″

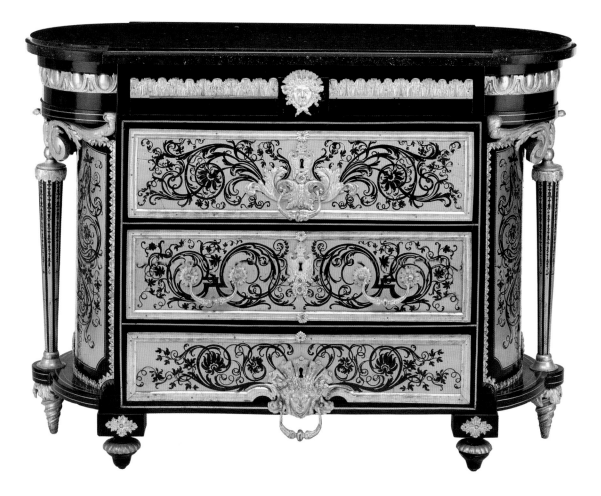

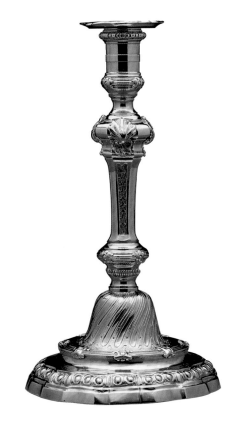

French silver candlestick, 1762–68. Height 10½″

McIlhenny continued to buy eighteenth-century English and Irish silver and enjoyed using it as much as possible. He regretted having so little French silver of the same period, which is so much rarer and more expensive. However, he was able to add to the Pacot centerpiece, which he had bought with his mother in 1937, four silver candlesticks from 1762–68, which were purchased from Arthur Sussel in Philadelphia by 1953. And other eighteenth-century French objects continued to enter the house, such as a charming marble of an infant holding a dove by Jean-Baptiste Pigalle, a variant on a piece commissioned by Mme de Pompadour, purchased from Rosenberg and Stiebel in 1960. McIlhenny loved eighteenth-century red chalk drawings; he bought two wonderfully fresh sheets depicting fashionable women by Louis-Rolland Trinquesse from the dealer Cailleux in Paris and four large drawings of the seasons by the sculptor Edmé Bouchardon that relate to the four reliefs of his most ambitious project, the 1739 fountain on the rue de Grenelle in Paris.

Rittenhouse Square began to fill up and take the form it would have until the end of McIlhenny's life, although the closing of Glen-

Louis-Rolland Trinquesse
French, c. 1746–c. 1800
A Young Woman Walking, Looking over Her Shoulder
Red chalk on light tan antique laid paper, $17^{11}/_{16}$ x $12^{3}/_{4}''$

Jean-Baptiste-Camille Corot
French, 1796–1875
The Aqueduct, c. 1826–28
Oil on paper mounted on canvas, 9½ x 17¼″

veagh and the transport to Philadelphia of many of the important things there caused a rethinking in the early 1980s. With the exception of the furniture, nearly all of which was chosen for a specific spot in the house, the objects were not acquired in accordance with any plan or particular order, but were the result of an inveterate collector exercising his taste in a diverse set of areas.

McIlhenny continued his programmatic and disciplined collecting of nineteenth-century paintings and drawings, although, given the immense increase in prices, at a slower and more modest pace. If the French paintings and drawings collected after the war lack the scale of many of the works purchased in the 1930s, they are of no lesser quality. When he saw Corot's *Aqueduct* at Alex Reid & Lefevre, London, which had it on consignment in 1953, he cabled his secretary in Philadelphia: "Have something sold if necessary but cable from Girard [bank] seven thousand dollars to the Berners Estate Company the Westminster Bank, Saint James." Years later, in 1985, he nearly "lost his head" (as he would say) when he almost bought another

Silver wine-glass cooler (monteith), 1704, by the English silversmith Samuel Lee (freeman 1701). Diameter 12¾″

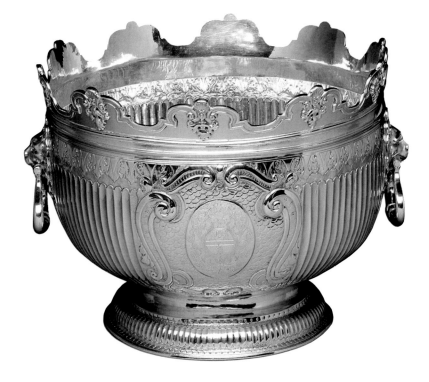

Italian sketch by Corot at the Gould sale in New York. The only thing that saved him was that he felt it was less good than his wonderfully direct and economical view across the Roman countryside.

In 1960 he bought the illusively simple charcoal drawing of baskets by Pissarro from the Impressionist scholar John Rewald and the next year, also in charcoal, the portrait by Gustave Courbet of Zélie, the artist's middle sister. At Gallerie Dabaer in Paris in 1962 he purchased the simple and effecting Cézanne drawing, *Peasant Girl Wearing a Fichu*, the perfect mate for his melancholy portrait of Mme Cézanne.

Ever since the 1930s, McIlhenny had been searching for a late pastel by Degas, the one area of the artist's work that was not represented in his collection. In February 1962 Alex Reid wrote him about the availability of *Woman Drying Herself*. McIlhenny knew it well from the collection of Dr. Georges Viau, whom he had visited in Paris before the war, and was, as he wrote the dealer, "desperately tempted even though it would mean using capital." The price, he wrote Angus Menzies, his friend and occasional agent in London, was incredibly high, particularly in comparison with the works by the artist he had bought in the 1930s. The pastel was sent on approval and McIlhenny scrambled successfully for the money. This purchase was a critical step in the creation of the collection, but it was not his last Degas. In 1966 McIlhenny bought from Wildenstein in New York the moody early drawing of René, the artist's younger brother, which had stayed with Degas's family for two generations. That same year he exchanged his Picasso *Composition* with the dealer Eugene Thaw as partial payment for Degas's delicate monoprint in the form of a fan, *The Foyer of the Dance*. He would add in 1971 another great drawing, a crayon and pastel, *Dancer Adjusting Her Shoe*, but that was eventually sold.

In 1970 a fourth Delacroix entered Rittenhouse Square: the large charcoal drawing *Allegorical Figure of Envy*. This brooding image with the disconcerting informality of a studio model—to whom wings have been attached for some still-unknown project, perhaps as an architectural spandrel—was bought as solace with part of the funds gained when he was forced to sell Seurat's *Les Poseuses*.

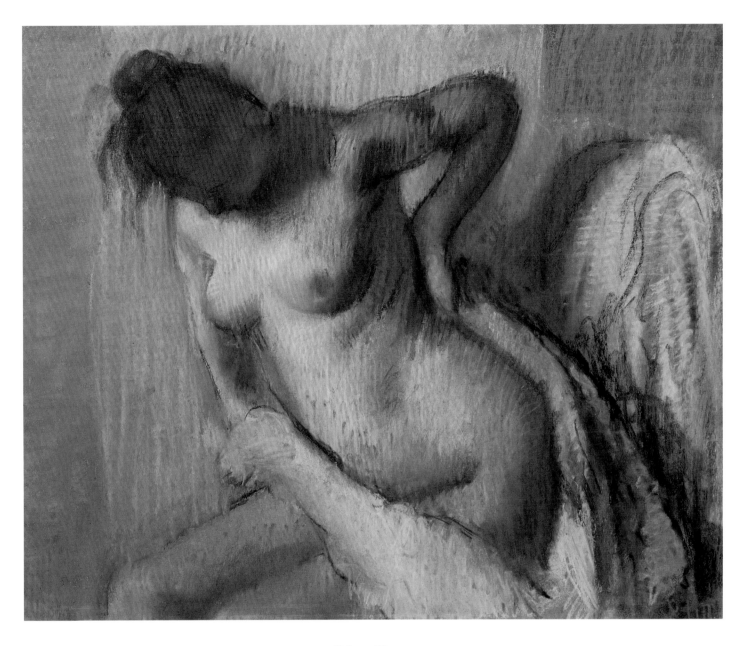

Edgar Degas
French, 1834–1917
Woman Drying Herself, c. 1886
Pastel on wove paper, 22¾ x 2¹/³/₄″

McIlhenny had long been an admirer of the bluntly simple van Gogh drawings in brown ink that reminded him of Rembrandt; in 1975 Robert Light in Boston sold him *Road at Saintes-Maries*, a work that could almost be van Gogh's homage to his Dutch heritage. Finally—and it was the last great nineteenth-century drawing he bought—the same dealer sold him in 1976 the early *Portrait of Gustav-Lucien Dennery* by Toulouse-Lautrec. While the characterizations in *At the Moulin Rouge* dissolve into the kaleidoscopic swirl of the night-life café, this drawing has the bold forthrightness of a figure, plainly witnessed.

At the same time there was a steady pace of objects coming and going at Rittenhouse Square. In 1960 McIlhenny went with friends on a long trip to India and while the great temples and sites interested him objectively, it was the amalgamation of two cultures in Anglo-India that added a new element to his collecting fervor. Over the

Japanese Arita-ware porcelain dish with decoration in the Kakiemon style, late 17th–early 18th century, with French ormolu mounts and marble, c. 1775–1800. Height 12″

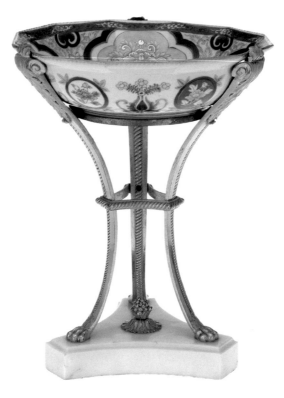

Vincent van Gogh
Dutch, 1853–1890
Road at Saintes-Maries, 1888
Ink with traces of graphite on off-white paper, 11½ x 19⁵⁄₁₆″

Thomas Daniell (English, 1749–1840)
and William Daniell (English, 1769–1837)
Sculptured Rocks, at Mavalipuram, on the Coast of Coromandel, 1799
Hand-colored aquatint, 15½ x 20⅝"

next twenty years he bought ivory inlaid chairs, a cabinet, and writing boxes of a type most often attributed to the craftsmen in the south of India, at Vishakhapatnam, working in the late eighteenth and early nineteenth centuries. In these pieces, English Neoclassical and Sheraton, or Hepplewhite, designs are freely maneuvered and applied with ivory inlays to create what McIlhenny thought was an enchanting solution to the aesthetics of two very different cultures. To these he would add a large set of prints done by Thomas and William Daniell, whose views of India could well have been of the English countryside, with the addition of exotic transplants. The same fascination with the East-West connection may be what prompted McIlhenny to add a pair of Japanese Arita-ware dishes with French ormolu mounts.

Ivory Anglo-Indian armchair with wood, metal, and cane, early 19th century. Height 38¾″

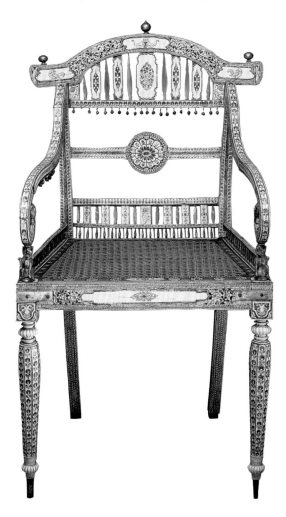

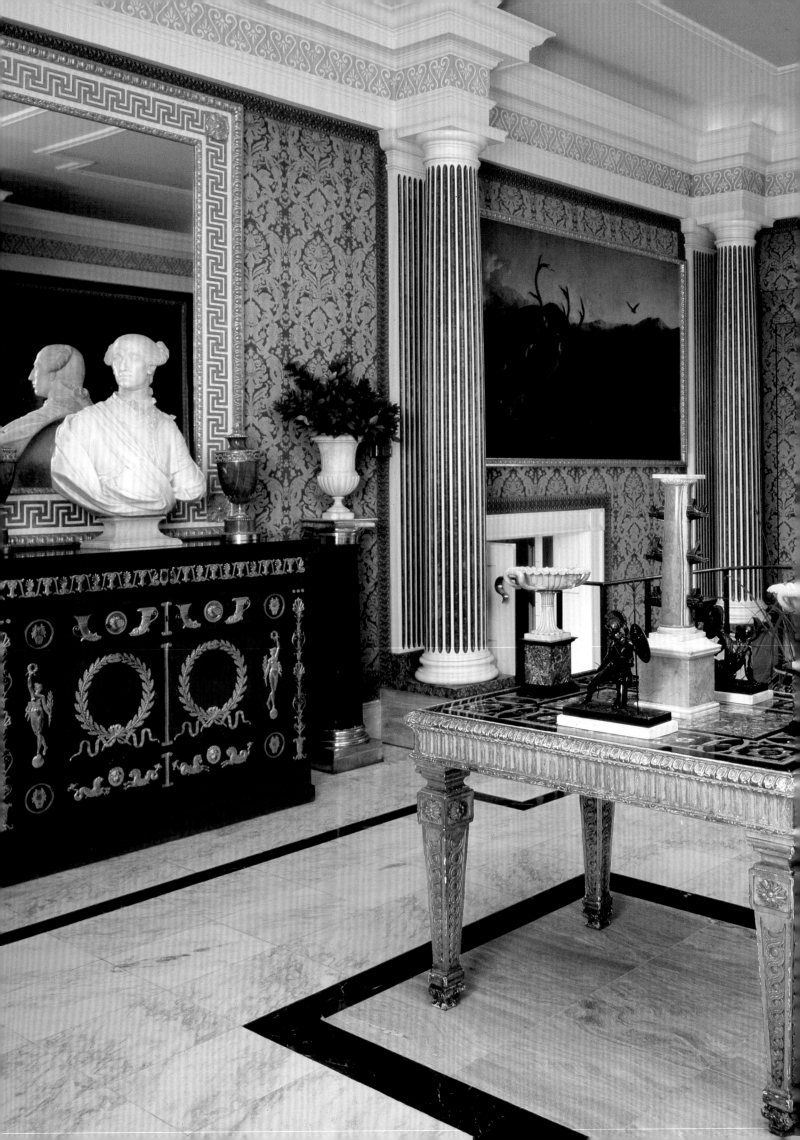

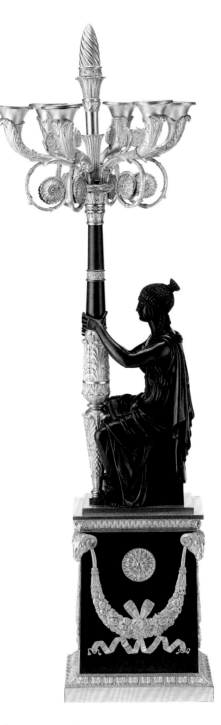

French patinated-bronze candelabrum with
ormolu mounts, c. 1810. Height 41″

The final pleasure—he enjoyed creating new spaces almost as
much as he relished filling them—was the transformation of the
Rittenhouse Square townhouse just to the east of No. 1914. McIl-
henny had bought the house in 1973 to create more quarters and
guest rooms—to "protect himself," he said—but especially to design
a ballroom that would be worthy of the parties he loved to give.

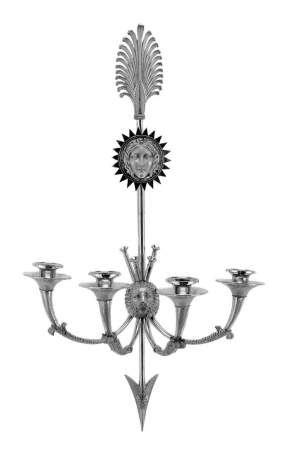

French ormolu wall light, after a model of c. 1809
made by the French bronze worker and gilder
Claude Galle. Height 25″

A Canova-style mantel, probably English, was found for the
ballroom, two crystal chandeliers that had been ordered but never
installed by a nineteenth-century maharaja were put in place, and a
showy (McIlhenny's word) eighteenth-century Florentine marble
bust of a nobleman in armor, with a remarkable subtle variety of
polished surfaces, was centered on one side of the room. But for all
this play with objects—he was, after all, creating a room for pure
amusement—he typically added one great piece: a Jacob desk, bought
at Fabius Frères in Paris. This object, with its deeply rich mahogany
finish and sparse placement of gilded ornaments, dominated the
room like an architectural element and introduced a sense of imperial
formality and dignity. McIlhenny bought it before the room was
finished; he knew exactly what he was doing.

If Glenveagh and Rittenhouse Square provided considerable dis-
traction, McIlhenny's life as curator at the Museum returned to a

more engaged involvement in the 1950s than it had since the war. Working closely with Louis Madeira, who became an assistant in decorative arts in 1948, and, starting in 1958, with the Museum's medieval and Renaissance decorative-arts specialist David DuBon, new collectors were wooed, among them Titus C. Geesey, whose rural Pennsylvania objects were installed in 1953. McIlhenny himself gave the Museum in 1984 a fine painted blanket chest, which he had bought in Bucks county in the 1940s. With the Museum's very limited acquisition funds, McIlhenny believed that its priority in the decorative arts should be important American objects, which were abundantly at hand in Philadelphia.

Writing cabinet (*secretaire-commode à vantaux*) of mahogany veneer with gilded-bronze mounts and marble top, c. 1803–13, by the French makers François-Honoré-Georges Jacob (1770–1841) and Georges Jacob (1739–1814). Height 46¼"

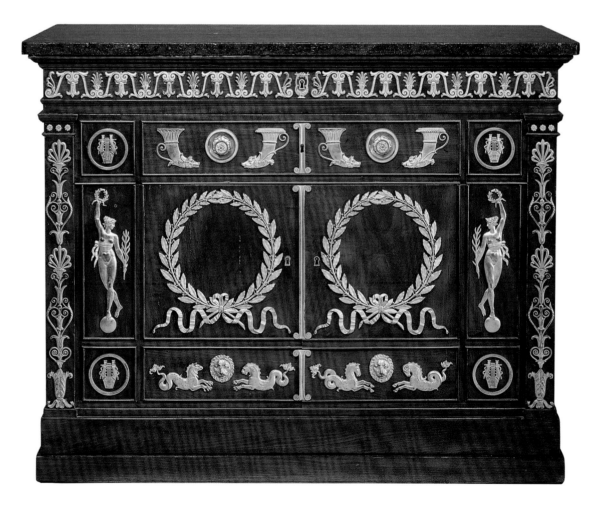

McIlhenny organized three major exhibitions of American decorative arts, each considered to be a landmark. When he was an assistant to guest curator William Macpherson Hornor, in 1935, he had worked on "Authenticated Furniture of the Great Philadelphia Cabinet-Makers." In the catalogue that accompanied the survey, Hornor noted: "An apogee was reached in the rocaille Chippendale and in its classically inspired rival, the Marlborough." Using this as a point of departure, McIlhenny's 1953 exhibition featuring two Federal furniture makers of Philadelphia, Henry Connelly and Ephraim Haines, who began their activities in the late eighteenth century, considerably advanced the preference for and knowledge of a more contained and upright style. The Federal style was very much to McIlhenny's taste; there were Federal pieces at Parkgate, and he

Mahogany armchair, 1800–1810, attributed to the Philadelphia cabinetmaker Ephraim Haines (1775–1837). Height 34½"

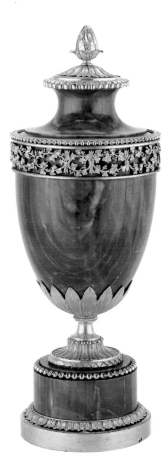

French marble urn with gilded-bronze mounts,
c. 1780. Height 21½″

continued to buy for Rittenhouse Square good works of this period
at the time of the exhibition. In 1956 he, Madeira, and the Museum's
silver specialist Beatrice Wolfe organized a survey of late-seventeenth-
and eighteenth-century Philadelphia silver, which was beautifully
installed in the painting galleries on the second floor. This critical show
brought together some of the most celebrated and best documented
pieces of this period, many of which have since found their way into
the Museum's permanent collections. Finally, the two men looked
to the third great achievement of Philadelphia's early craftsmen and
in 1957 organized an exhibition devoted to America's first successful
porcelain works: "Tucker China, 1825–38." An exhibition of Shaker
material in the spring of 1962 was McIlhenny's last major project,
which he carried off in close collaboration with Madeira.

The Museum had been able to acquire major French and Italian
decorative and architectural works from the Renaissance since the

1930s, many of the most spectacular from the collection of the French connoisseur Edmond Foulc. But these objects had been exhibited in a provisional installation; with David DuBon, McIlhenny began planning a carefully designed installation for this material in 1960. Quarry stones were tested for wear, stuccoed walls restuccoed numerous times, and measurements missed and remeasured. It was an absolute collaboration between the two men and the resulting spaces on the second floor are some of the most handsome in the Museum.

McIlhenny's retirement in 1964 from the curatorial position he had held since 1934 was a new source of reactivation in Museum affairs. He immediately became a trustee of the Museum. His search for works on the market (often in the company of curators) increased and broadened, and he urged his colleagues to canvas the dealers, even though acquisition funds were limited: We "must marvel at the miracle that the Museum here ever buys anything." In 1976 he was elected chairman of the Board of Trustees, and his house on Rittenhouse Square became an extraordinarily hospitable extension of the Museum. McIlhenny served on committees to find two directors, and at the time of his death he was chairman of the institution's largest fund drive. But even with all his new chores, he kept a careful eye on the Museum, and woe betide the curator with pictures of secondary quality hanging on the walls or an underdecorated period room spotted during McIlhenny's frequent sweeps through the galleries.

Camille Pissarro
French, 1830–1903
Baskets, c. 1889
Black crayon on off-white laid paper, 9¼ x 11⅞″

Sir Edwin Landseer
English, 1803–1873
Duchess of Bedford's Hut, Glenfeshie
Oil on board, 23½ x 17½"

AFTERWORD

H ENRY McILHENNY'S LIFE IN THE ARTS WAS A REMARKABLE achievement. He loved abundance and luxury, and he enjoyed tremendously taking what his appetite for richness brought him and forming it, in Ireland or Philadelphia, into a splendidly livable whole. Watching him take over a rented property to make it his own for three months was nearly as much fun as following the more plotted redoing of his own spaces. And as closely as he is associated with individual works of art of great magnitude, the creation of comfort for himself and his friends was as important to him—completely inseparable, in fact—as the accrual of beautiful things. He was wonderfully self-assured in his decisions: "My, haven't I chosen well."[31] Yet, there are clear principles that governed the creation of his collection, many of which he had first learned from Paul Sachs at Harvard in the early 1930s. As valuable as objective information and discipline must be in making choices about works of art, there is always that overriding component, the deeply personal interworkings of taste and self-knowledge, that finally holds together all great collections.

The determination to collect seriously nineteenth-century French paintings and drawings set early and he never spent, proportionally, such large amounts of money on any other kind of art. Picking a field in which to collect and holding to it was an absolute principle for him, and he often repeated this dictum. In turning down a beautiful Renaissance painting by Cosimo Tura on one occasion he reiterated: "I have always tried to discipline myself sticking to the French School of the nineteenth century, and it really does make sense, and actually I would much rather have another early Corot."[32] His greatest frustration was that he could not, given the limits of his finances and the rising market, pursue this chosen field after the war with the intensity he had in the 1930s. Until the end of his life, however, he continued the formation of his collection as an ideal

whole. Two great painters were missing from his French pantheon: Manet and Géricault. For the first, he sometimes argued that it was less critical since, thanks particularly to the Tyson family, the Museum was already rich in Manet. But, Géricault haunted him and one of his last efforts, failed alas, was to bid on two pictures by this artist from the Hans Bühler sale in 1985 (both went to the J. Paul Getty Museum).

The gathering of nineteenth-century English paintings was a more relaxed process. Pictures were bought in a more casual way, accommodating new spaces as they were created. Yet, in retrospect, there are clear patterns here as well. He particularly enjoyed these overblown and sentimental Romantic pictures, with their emotionally charged narratives and anecdotal asides. Certain parallels could be drawn between these and his French pictures, where indeed the human figure predominates and intense characterization is of greatest importance, be it in the subliminal drama of Degas's *Interior* or the profound human misery of van Gogh's *Rain*.

It is more difficult to discern a clearly defined pattern in the sensibility that chose the decorative arts. Certainly McIlhenny's taste was often for the geometric and symmetrical as reflected in his French Empire and Restoration furniture, Neoclassical marbles and silver, Philadelphia Federal furniture, and even the Anglo-Indian objects. Such notions are quickly qualified, however, by such exuberantly Rococo pieces as the two English silver epergnes, neither of which contains a single still line. In all areas of his collecting, restraint was much valued, but nothing could be too dry or conspicuously studied. He was offered, for example, David's sketchbook for the *Coronation of Napoleon*, which went instead to Grenville L. Winthrop (and is now in the Fogg Art Museum). It was a logical and highly important object for the man who owned one of the major studies for this monumental painting, but he was not interested in it and often commented on the irony that, for him, David was one of the greatest of all painters but his drawings were usually "too clinical."

For McIlhenny the grand line of French art in the nineteenth century began with David and not with the Impressionists. As he noted in a review of the huge nineteenth-century French painting

exhibition held at the Metropolitan Museum of Art in 1941, the greatest limitation of American museums was still the absence of Neoclassic and Romantic works in quantity and significance to match those from the second half of the century.[33] He shared these views with his colleagues from Harvard, along with a conviction about the importance of knowledge and appreciation of the art of one's contemporaries. This commitment to modernism is reflected in a letter he wrote to his mother from Norfolk, Virginia, just as he was departing for war, in 1942, encouraging her in her trusteeship of the School of Industrial Art:

> *The School . . . does make me mad. There isn't one person on the faculty that likes or understands modern art. . . . A really extreme modernist is required, or the school will die on its feet. Please try to say something at the next Trustees meeting. You know it's your duty as a Trustee and as a collector and supporter of contemporary art. The students should be taught the newest along with the old, and unless that is done, the students are being gypped.*

During the 1950s, his opinions would shift, and his sister, who continued to be more caught up with events in contemporary art, would surpass him in this area. As much as he would complain about certain developments (particularly the prices fetched by new works, which, for McIlhenny, were still critically untested), until the end of his life, any artist, whether a student or a figure of great stature, was always warmly welcomed to his houses. There are many mementos of these visits, most charming perhaps, a drawing of Cecil Beaton's feet by Andy Warhol, sketched while Beaton was napping in McIlhenny's garden in Philadelphia.

McIlhenny's taste for nineteenth-century French painting followed that of Sachs and his Harvard friends. If one had to point to a specific parallel, the collection formed by Grenville Winthrop (a man of McIlhenny's father's generation whom he knew only formally, but often visited in New York) certainly provided the clearest standard for his ambitions. His interest in French Empire and Resto-

ration furniture may be credited with a greater sense of innovation, and he shared an enthusiasm for this style with very few when he began buying these objects in the mid-1930s. Mario Praz, in *On Neoclassicism* of 1940, would still complain of how few collectors really appreciated the Empire style, and even for him, works postdating the Empire—Restoration pieces from the 1820s and 1830s such as those by Jeanselm and Werner, for example—were of dubious distinction.[34]

The very low prices paid for the nineteenth-century English pictures also argue for his advanced understanding, and while the present-day appreciation of these artists always pleased him, he was simply acting on the taste of a person who, at the age of ten, as his mother reported, was sorely disappointed that the Landseer galleries were closed at the South Kensington (Victoria and Albert) Museum. For him these pictures were comfortably old-fashioned, and fit well in the context of Glenveagh, but not an overriding passion. As he wrote the London dealer Hugh Leggatt in 1954: "It is sad to think that I was shown a Landseer at Wildenstein's in New York. I am afraid the happy hunting days are doomed." But his regret was never of the true depth of not getting one more Cézanne, Degas, or Delacroix. A phrase that reoccurs in letters to dealers offering him great pictures throughout the years is that "it breaks my heart to say no," and he meant it.

McIlhenny was rarely philosophical or emotional about his collection either in conversation or, least of all, in writing, except sometimes to his mother or sister. He knew what he had was unique, and as time went on, he too understood that there was something remarkable about his choices, far beyond notions of art-historical importance or quality in the conventional sense. In each of the great objects there is something—an emotional charge, an edge, a power holding one's attention far beyond the exercise of analysis or study—that sets it apart. He had no fear of sentiment, although quite an unsentimental man himself, and he was very knowing about his life and his possessions. They, like his friends, whom he so easily mixed with his beautiful things, formed a kind of golden unity.

to henry

Cecil Beaton's feet

Andy Warhol

Andy Warhol
American, 1928–1987
Cecil Beaton's Feet, c. 1955
Ink on buff wove paper, 16¾ x 13⅞″

This was well understood by McIlhenny's good friend the celebrated poet Stephen Spender, when he came to stay one dreary February weekend in 1979:

> *Sunday with Henry McIlhenny. It was delightful to be in his house for twenty-four hours, with a really comfortable bed, servants, excellent food and Henry's exhilarating conversation and gossip. I suppose the key to H.'s personality is that he counts his prodigious blessings every day, is enormously grateful for them, and lives up to them. He gives life and spirit and lessons in tolerance to the people in Philadelphia with whom he consorts. They all seem covered in gold plate and one never knows what he thinks of them. Completely sceptical, he is also not in the least disillusioned. He sees illusions as illusions and thoroughly enjoys them for being that. Someone told me this weekend that the painter who did the portrait of Henry as a languid young man dominated by an enormous piece of furniture, which fills up most of the canvas, had meant to convey that H. was overwhelmed by his possessions. Many years later he said, "I was wrong. He is completely in possession of his possessions."[35]*

In bequeathing these possessions so unreservedly to the institution that he and his family helped form, McIlhenny has extended his confidence in the collection still another step. The bequest is a remarkably generous act and one full of warmth and self-understanding. The objects will transform numerous areas of the Museum's collections, many of which he had such a direct hand in creating during his lifetime. Henry McIlhenny fully understood the power of his legacy.

NOTES

Unless otherwise credited, all quotes are from the papers and correspondence of Henry P. McIlhenny or from departmental correspondence in the archives of the Museum.

1. Charles A. Loeser (1864–1928), a Harvard-trained American collector living in Florence, served through his friendship with American collectors as both friend and rival of Bernard Berenson. Richard Offner (1889–1965) was, after Berenson, the most respected authority on Italian painting of his generation.
2. See Charles Grant Ellis, *Oriental Carpets in the Philadelphia Museum of Art* (forthcoming).
3. The Museum held a memorial exhibition of John D. McIlhenny's collection in the winter of 1926; see *Pennsylvania Museum Bulletin*, vol. 21, no. 100 (February 1926). The final selection, with works added by Frances P. McIlhenny, was shown and catalogued in 1944; see *Philadelphia Museum Bulletin*, vol. 39, no. 200 (January 1944).

4. Ground was broken on the new site of the Museum by 1919 although the actual building did not open until 1928.
5. Valentiner was an expansionist in terms of painting attribution and, in the case of the McIlhennys, seems to have inflated minor painters well out of proportion. The rest of his career was considerably more successful; he created major public collections in Detroit, Los Angeles, and Raleigh, North Carolina. Paintings were never McIlhenny's first love, and they took a second place to Oriental carpets. See Margaret Heiden Sterne, *The Passionate Eye: The Life of William R. Valentiner* (Detroit, 1980).
6. The Museum chose twelve pieces of English porcelain from McIlhenny's collection that he had inherited from his mother.
7. Agnes Mongan and Paul J. Sachs, *Drawings in the Fogg Museum of Art*, vol. 1 (Cambridge, 1946), p. viii.
8. Ibid.
9. Grand Palais, *Chardin* (Paris, 1979), p. 138.

Set of silver tea caddies and a sugar box, 1754, by the French silversmith Louis Guichard (active London, mark entered 1748). Height 5⅛″

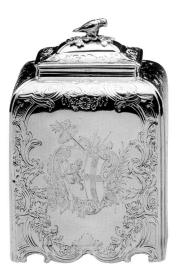 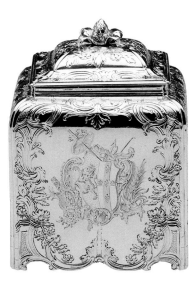 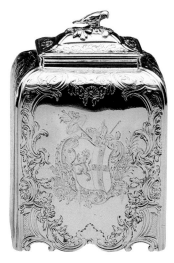

10. This small work, now in the Philips collection, Eindhoven, has recently been catalogued among doubtful works formerly attributed to the artist; see Max J. Friedländer, *Pieter Bruegel* (Leiden, 1976), no. 6.

11. The Renoir in the collection of John Nicholas Brown, Providence, was the pen, ink, and chalk of about 1877–78 of a young woman on the boulevard made, but never used, as an illustration to Zola's novel, *L'Assommoir*. See John Rewald, ed., *Renoir Drawings* (New York, 1946), no. 4, pp. 15–16; and Fogg Art Museum, *Forty Master Drawings from the Collection of John Nicholas Brown* (Cambridge, 1962), no. 23.

12. The exhibition at the Orangerie was organized by Paul Jamot, as a member of the organizing committee; see Musée de l'Orangerie, *Exposition Renoir 1841–1919* (Paris, 1933).

13. Theodore Reff, "Degas's 'Tableau de Genre,'" *The Art Bulletin*, vol. 54, no. 3 (September 1972), pp. 316–37.

14. Paul-André Lemoisne, *Degas et son oeuvre*, 4 vols. (Paris, 1946).

15. See Joseph J. Rishel, *Cézanne in Philadelphia Collections* (Philadelphia, 1983), p. xvi.

16. The architectural firm of Carlhian created reproductive interiors early in the century, including those for the Frick Collection.

17. See Philadelphia Museum of Art, *The Second Empire 1852–1870: Art in France under Napoleon III* (October 1 – November 26, 1978).

18. Jacques-Louis David, *The Coronation of Napoleon I, December 2, 1804*, 1806–7, oil on canvas, 244½ x 385⁵⁄₁₆" (Paris, Louvre).

19. Rosamond Bernier, "Le Musée privé d'un conservateur," *L'Oeil: Revue d'Art Mensuelle*, no. 27 (March 1957), pp. 20–29.

20. *Violins*, 1912, oil on canvas, 29½ x 24". Carey Walker Foundation as of 1973. See Pierre Descargues and Massimo Carrà, *Tout l'oeuvre peint de Braque, 1908–1929* (Paris, 1973), no. 93. The present whereabouts of *Wine Glass* are unknown.

21. *The Black Clock* is now in the collection of Stavros S. Niarchos, London.

22. Numerous modern works (including a head by Derain and a painting of gladiators by de Chirico) were among those sold (New York, Parke–Bernet Galleries, June 5, 6, 7, 1946).

23. McIlhenny worked on the Irish gardens with his Harvard classmate Lanning Roper; see Jane Brown, *Lanning Roper and His Gardens* (New York, 1987), pp. 75–84.

24. John Cornforth, "Glenveagh Castle, Co. Donegal: The Home of Henry P. McIlhenny, Part I," *Country Life*, vol. 171, no. 4424 (June 3, 1982), p. 1636.

25. Cambridge, Fogg Art Museum, *Grenville L. Winthrop: Retrospective for a Collector* (January 23 – March 31, 1969), esp. nos. 89, 110, 111, 112, 113.

26. Kelly executed three drawings of this tree, retaining one for himself and giving one to McIlhenny and one to the Pulitzers.

27. New York, Museum of Modern Art, *Franklin C. Watkins* (March 21 – June 11, 1950).

28. John Richardson, "Connoisseurship on Rittenhouse Square," *House and Garden* (December 1986), pp. 115ff.

29. See *Philadelphia Museum Bulletin*, vol. 46, no. 228 (Winter 1951), pp. 28–35.

30. These double townhouses are now The Rosenbach Museum and Library.

31. To Bernice Wintersteen, November 7, 1943.

32. To David Carritt, March 22, 1954.

33. See Henry P. McIlhenny, "'David to Toulouse-Lautrec' at the Metropolitan Museum," *The Art Bulletin*, vol. 28, no. 1 (March 1941), pp. 170–72.

34. First published in Italian; see Mario Praz, *On Neoclassicism* (London, 1969).

35. Stephen Spender, *Journals 1939–1983*, ed. John Goldsmith (New York, 1986), p. 338.

ENDPIECE

Venus and Dolphins, 1799, by the Swiss sculptor Heinrich Keller (1771–1832) shown in the garden of McIlhenny's Rittenhouse Square townhouse. Marble, height 40"

ACKNOWLEDGMENTS

Many friends and colleagues of Henry McIlhenny have contributed generously to the preparation of this essay. The sons of his sister Bernice McIlhenny Wintersteen—John, Jr., James McIlhenny, H. Jeremy, George F.—have given us access to the McIlhenny files, photographs, and correspondence, which provided the foundation for our research. Katharine Norris and Patrick Gallagher made our use of these papers at 1914 Rittenhouse Square tremendously agreeable, and Mr. Gallagher, who with members of his wonderful family had worked for McIlhenny in both Philadelphia and Ireland since 1954, kept us particularly on track. Conversations with Agnes Mongan, Perry Rathbone, and Joseph Pulitzer provided stimulating information and opinions about McIlhenny's student life at Harvard and some of his later attitudes. Edgar Peters Bowron, director of the Harvard Art Museums, was very generous, particularly in sharing his lecture notes and research from the Fogg's archives on Grenville Winthrop. Three of McIlhenny's closest friends, Gloria and Emlen Etting and Priscilla Grace, read the text of the manuscript: Their observations have helped shape what is presented here.

At the Museum, each of the departments involved has provided much helpful information. Louise Rossmassler's splendid ordering of the Museum's archives has made investigation into old departmental papers and Fiske Kimball's correspondence a model of accessibility. The registrars have been expedient in researching exhibition files. The entire conservation staff has applied itself with tremendous organization and energy to prepare works for photography and the exhibition. Conna Clark, Eric Mitchell, Joseph Mikuliak, and Will Brown have gone well beyond the expected in preparing photographs. Colin Bailey has made constructive observations throughout the preparation of the manuscript; Margaret Quigley has coped with an unswerving intelligence and patience in preparing the manuscript and the support material for it. Alice Lefton, as research assistant, has been central to this whole project. This book has been edited by George H. Marcus and Carolee Belkin Walker.

The installation of the exhibition follows the designs of Cleo Nichols; all details have been carried out by Lawrence Snyder, David Wolfe, Lee Savary, and the Museum's installation crew.

J.R.